Google+

for Photographers

Colby Brown

Peachpit Press

Google+ for Photographers
Colby Brown

Peachpit Press
1249 Eighth Street
Berkeley, CA 94710
510/524-2178
510/524-2221 (fax)

Find us on the Web at www.peachpit.com
To report errors, please send a note to errata@peachpit.com
Peachpit Press is a division of Pearson Education

Copyright © 2012 by Colby Brown

Acquisitions Editor: Cliff Colby
Project Editor: Valerie Witte
Production Editor: Katerina Malone
Developmental Editor: Anne Marie Walker
Copyeditor: Anne Marie Walker
Proofreader: Scout Festa
Composition: Kim Scott, Bumpy Design
Indexer: Joy Dean Lee
Cover Photos: Colby Brown
Cover Design: Mimi Heft
Interior Design: Mimi Heft

ISBN-13: 978-0-321-82040-2
ISBN–10: 0-321-82040-1

9 8 7 6 5 4 3 2 1

Printed and bound in the United States of America

To my supporting and loving wife, Sarah; my adorable son, Jack; and all those who choose to follow their passion for the art of photography.

Acknowledgments

As a photographer first and a writer second, I found that it is often easy to overlook the logistical and creative challenges that are part of the process of writing and publishing a book—let alone a book that people enjoy. The reality is that although I spent countless days researching and writing the content for this book, I was certainly not without support from many individuals who helped to put together what you see before your eyes. Without them, this book would not be what it is.

Throughout all my travels, the late nights, and the weekends I spend working on countless projects, my family has always been there to support me. Their love, compassion, and understanding help to drive me to follow my heart with everything I do. Sarah and Jack, my heart is forever yours.

To all of the contributors to this book, I want to thank you for your time, energy, and creativity. Thank you to Dave Cohen, Brian Matiash, Jay and Varina Patel, Scott Jarvie, Catherine Hall, Patrick di Fruscia, Alex Koloskov, Trey Ratcliff, and Elia Locardi for sharing your wisdom and thoughts on Google+ and photography in general. Thank you to Mark Waslick, Melaine Schweighardt, Jacob James, and Grayson Hartman for being selected to be a part of this book by opening up and sharing your moving experiences about your time on Google+ as aspiring photographers.

To Google and your employees, thank you for patiently answering my endless questions. It was truly a pleasure to work with you to make sure this book was as accurate as possible.

To the Peachpit team and all those who worked on this book, thank you! Without your help, creativity, expertise, and most important, patience, this book would not have been possible. To Anne Marie and Valerie, especially, thank you for the guidance and time you spent working with me. It certainly was not easy to write and publish a book as quickly as we did, and without your help I would have been lost.

And lastly I want to thank the photography community on Google+. Every day I am inspired and moved by your willingness to share not only your photography work, but pieces of yourselves as well. The close connections and relationships I've formed on Google+ are unlike any I've developed on an online network before. It has truly been a pleasure getting to know many of you over the last few months, and I look forward to meeting more people every day.

Contents

Introduction

When I first started my career as a photographer, online networks for photographers were still in their infancy. Yahoo's Flickr was easily the most prominent, but even then it was only a fraction of what it is today. At the time, I saw no point in utilizing these resources because in reality I did not know they were viable resources. Instead of having the ability to easily share my work with the world, I relied on the support of friends and family. Instead of increasing my knowledge of postprocessing my images by watching a YouTube video or stumbling across a blog article, I read every book I could find on the subject. Instead of finding a wide variety of potential customers and clients in a single location, I marketed myself the old-fashioned way, by word of mouth. Although I am certainly grateful for these experiences because they have helped shape my various photography businesses and me into what we are today, I can't help but look at how much online networks have helped change the photo industry.

One of the most exciting aspects of being a photographer today is not only the access to affordable camera gear, but also the ability to engage and interact with other individuals who share in your passions and interests. It doesn't matter if you are a seasoned professional or a novice with your first digital camera, the opportunity to connect with others to increase your knowledge, share your experiences, and even market to new customers and clients is just a mouse click away. Between message boards, photo sharing websites, and online social networks, photographers have more than their fair share of choices. However, for many, it has been confusing to figure out where to spend their time and energy. But once Google entered the online networking world with Google+, that all changed.

A Photographer's Perspective

Although Google+ has one of the most active and engaging communities of photographers on the Internet, finding your footing in a new network can be challenging. This book originally started out as a guide on my blog titled "Google+: A Survival Guide to a Photographer's Paradise," which was read by over 500,000 people. Although the guide focused purely on step-by-step instructions on how the features of the network worked, my

goal with this book was to expand upon just the feature set and show you how to best utilize the network to help you build a following and establish an online presence as a photographer. Each chapter features an interview—"A Photographer's Perspective"—with some of the most influential photographers in the photo industry, giving you an inside look at how these professionals utilize Google+ on a daily basis. By working directly with the Google+ team of engineers and employees, I was able to make sure the information in this book is accurate and relevant.

What Google+ Means to You

In the end it is the photo community that makes any network a great resource for photographers. In December 2011, I held an open contest on Google+ that gave four aspiring photographers the opportunity not only to be featured in this book, but to tell their personal stories of why they have made Google+ their home. Spread throughout this book you'll find the winners of this "What Google+ Means to You" contest. These essays reflect the growing and supportive nature of the network and will hopefully give you some insight to the endless potential that can be found with Google+.

With this I want to welcome you to join Google+, get your feet wet, and utilize the content of this book to help guide you along the way. If you still have questions, do not hesitate to engage with the photography community on the network or ask me directly. Needless to say, a simple Google search will point you in the right direction.

Credits

+1

Why Google+ Works for Photographers

As a photographer, there is certainly no shortage of online venues to showcase your images, interact with other artists, market to potential clients, and learn to improve your craft. From Facebook to Twitter, Flickr to 500px, photographers have constantly been forced to utilize the tools that were available rather than focus on what was missing. Although each of the networks can be beneficial to a photography business in its own way, most networks are typically structured in a way that makes it difficult to build a following or interact with people in meaningful ways. In the past, you had to use a mix of all of the major networks and image-sharing websites to fulfill your photographic needs. That was then. This is now.

At its core, Google+ is based on three concepts: search, social interaction, and control. The foundation of the network utilizes these concepts in a way that makes you feel as though it was designed with photographers in mind from the start. Never before have you had the opportunity to connect and interact with some of the top photographic professionals in real time or find so many photographers with similar interests in a thriving and engaging online community. And never before have you been able to control nearly every aspect of your experience in a social network. When you combine these core concepts with a simple yet sleek user interface and a layout that displays your photographs better than any other online network, it is no wonder that the photography industry has jumped head first into using Google+.

In this chapter I'll focus on explaining what Google+ truly is. I'll talk in detail about the core concepts that separate Google+ from the rest, the truth about controlling the rights to your images online, and Google's hands-on approach to social networking.

What Is Google+?

Google+ (**Figure 1.1**) is unlike any other network on the Web. It is an information and media-streaming powerhouse. It is a system that is not only structured to promote interaction, but it thrives on it. However, to fully understand Google+, you can't compare it to Facebook, Twitter, Flickr, or 500px. It is something new, something unique, and something many of us in the photo industry have been waiting for.

Social Networks vs. Interest Networks

A common misconception of Google+ is that it should be used like Facebook. For this reason, many individuals feel lost when they sign up because they try to interact on the two networks in the same way. I'll let you in on a little secret: They are not the same. To better understand the distinction, let's look at the difference between social and interest networks.

Defining social networks

In a social network such as Facebook, most users spend their time interacting with those they have a close relationship with. For example, Facebook initially started out on a single college campus, Harvard University. The idea was to connect and interact with other students from the same school in ways that were not possible before its inception. Over the years,

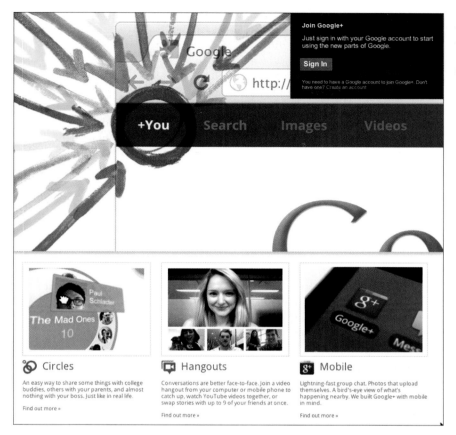

Figure 1.1 The Welcome page for Google+ just before you initially sign up.

Facebook has certainly expanded and evolved, but at its core it continues to maintain its closed group mentality. Although the addition of Facebook Pages and Groups has attempted to fix this issue, the very nature of what made Facebook so popular conflicts with this expansion. This is one of the reasons that it is difficult to create a Facebook page for your business and gain a following as a new photographer. Shared interests and a sense of community are present, but they always take a back seat to the true reason the average Facebook user is on the network, which is to connect with those they already know.

Defining interest networks

In contrast, interest networks focus on connecting individuals that have similar interests. Flickr and 500px are perfect examples. If you are passionate about photography, you are more likely to join these networks because there is a common bond present. However, you are less likely to find your

grandmother and best friend on Flickr unless they too share that same passion. The benefit of these networks is that you can surround yourself with other individuals who share your pursuits and interests. As a photographer, you can connect, engage, and collaborate with other artists who you might never have met in real life.

The obvious drawbacks to an interest network are typically the limited nature of the focus of the community and the lack of personable interaction that you otherwise find on social networks like Facebook. Although Flickr and 500px are two of the best online sites to find beautiful photographs, you probably won't get much out of them if your passion is music or you want to stay in touch with family members.

How does Google+ fit in?

When it comes to trying to define Google+, it is much more challenging than you might think. Just as relationships organically develop in your lives, the interactivity on Google+ is as dynamic, diverse, and complex as you want to make it. Google+ takes the meaningful interactions of a social network and the sense of community development of an interest network and creates something new and exciting. Photographers, artists, and potential clients interact, support each other, and connect unlike ever before.

Although the photography community is one of the largest on the network, thousands of small communities thrive on the network as well. In a sense, Google+ is about discovery, learning, and engaging with others who you might not have known about otherwise.

Core Concepts of Google+

As mentioned earlier, at the core of Google+ are three concepts that help shape the network and separate it from the rest: search, social interaction, and control.

Focusing on search

One of the most ignored benefits Google+ has over other online networks is Google's role on the Internet. As a company, Google is the king of search on the Web. In what started out as a research project back in March of 1998, Google now controls close to 66 percent of all online searches, according to a study by Hitwise on October 13, 2011 (**Figure 1.2**). Therefore, it is only natural that Google implements its complex and sophisticated search algorithms into Google+.

One of the main benefits of utilizing Google+ is the fact that your interaction on the network has the potential to influence search results. Currently,

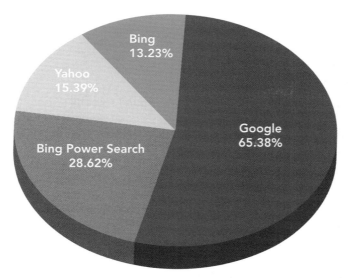

Figure 1.2 Internet search totals for October 2011. Source: Experian Hitwise.

Note: Data is based on four-week rolling periods (ending Oct. 1, 2011, and Oct 29, 2011) from the Hitwise sample of 10 million U.S. Internet users. Figures are for Web searches only. Data does not include mobile search.

Source: Experian Hitwise

Internet search results are dictated by a number of factors, most important of which is SEO (Search Engine Optimization) for content found online. SEO is basically the use of methods or techniques to improve the visibility of a website on the Internet. For example, as a photographer, it is important to make sure you have important keywords listed on the home page of your website because it is the first page that is indexed (searched). On the home page of my photography website is an introductory paragraph that not only describes who I am, but also contains many important, searchable keywords, such as "Colorado," "landscape," "humanitarian," "workshops," and "author." These keywords can play an important role when clients or customers are performing broad online searches. You'd be surprised at how many contracts I have landed because a client searched for "Denver Landscape Photographer." Because Google allows all content you choose to publish publicly on Google+ to be searchable, this begins to change the value of SEO on the Internet.

So how are SEO and Internet search results influenced by Google+? Google's "Search Plus Your World" initiative is the answer. At the start of 2012, Google announced that it would favor and begin to integrate Google+ content into the search results it provides to users who are signed into a Google account (Gmail, YouTube, Google+, etc.). Which Google+

Colby's Quick Tips

The more you engage with your followers on Google+, the more they will interact with the content you publish. You must stay active and be willing to put in the time, but in the end it will be well worth it as your business begins to grow and your search results begin to climb.

Figure 1.3 The Google +1 button helps to influence search results.

Figure 1.4 The Google+ search bar is found at the top of every page on Google+. It can help you find a variety of information.

content appears in a user's search results are influenced by the +1 button (**Figure 1.3**) and who you are connected with on Google+. When you connect with someone on the network and add them to your circles, content that those individuals publish will begin to show up in your search results if it is relevant to your initial search. When you click on the +1 button that is found throughout Google+ and on most websites, you are in essence recommending that content to those who follow you on the network. If enough people have clicked on the +1 button for one of your posts, there is a much higher chance it will be showcased in another user's search results, because it has been recommended by a number of people. While this feature is optional and can be turned off easily, one can imagine the impact this has on more individuals finding the content you publish online if you are active in Google+.

In addition, you can always use Google's search algorithms within Google+. Have you ever posted a photo on Flickr or seen an interesting post on Facebook but couldn't remember where you saw it? Have you ever wanted to find a post you published six months ago but didn't want to wade through all of your content to find it? Have you ever wanted to connect with other local photographers but didn't know where to start? As a professional photographer, I've personally experienced all of these challenges many times and have always been amazed at how many networks work against you rather than for you. With the Google+ search bar (**Figure 1.4**), finding content, an individual, or a community has never been easier.

Going beyond social interaction

At its heart, Google+ is about social interaction, connecting, engaging, and discovering with others who share your interests in ways that go beyond your standard online social networks. Although Google+ is still in its infancy, it is already the fastest growing online network in history. In just 16 days from its launch, it had 16 million users, a feat that took Twitter 780 days and Facebook 852 days. Now, it has pushed past 100 million users. These numbers are a testament to the changing tide of social engagement online. People understand the complexities of these human relationships and are looking for something more than just the superficial interactions of the past.

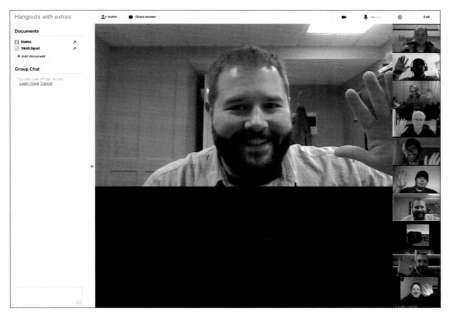

Figure 1.5
Google+ hangouts allow you to directly connect with individuals worldwide via webcam and microphone through video conferencing technology.

The popularity of Google+ Hangouts (**Figure 1.5**) is a great example of this change in thought. *Hangouts* are basically group videoconferences that allow you to connect in real time with nine other individuals (ten in total) from anywhere in the world. Using webcams and microphones, you can interact, watch videos, and even share your computer screen with others. Not only does this open the door for some very creative ways to engage with colleagues, clients, and customers, but it offers endless ways to teach and learn from others within the photographic community.

Controlling your interactions

As we have moved further and further into the digital age, the importance of control, or choice, is becoming more apparent. Although every online network gives you tools for connecting with other individuals, they don't always make it easy for you to fine-tune how you interact. In the real world, life is not always a two-way street but instead is a complex mix of interpersonal relationships that sometimes overlap. On a given day, you might interact with 15 different individuals, but that doesn't mean you treat those relationships the same or share the same information with each of those people.

Enter Google+ Circles (**Figure 1.6**). *Circles* are Google's answer to the beautiful complexities of human interaction. They not only function as a means of grouping individuals together that you want to share specific

Figure 1.6
Google+ circles
allow you to easily
control who you
connect with.

information and content with, but they also act as filters to sort through
the content you see and interact with on a daily basis. As with all things
on Google+, you can utilize this feature as you see fit. Do you just want to
have one big circle and throw everyone in there? Not a problem. Do you
want to create separate circles for clients, customers, local photographers,
friends, and graphic designers? You can do that too. In the end, you have
control over what you publish, whom you publish to, and how you choose
to interact with those you are connected with.

Aesthetics Matter

As artists, it should be no secret that aesthetics matter. As photographers,
we are constantly looking for new and creative ways to capture the beauty
of life on this planet. From beautiful sunsets to family portraits and even
graveyards, each of us is subjectively looking to capture something beauti-
ful (**Figure 1.7**). So why does it seem as though so many websites on the
Internet never got this memo?

Figure 1.7
"A Beautiful Return
Home" taken in
Thailand. ©Colby
Brown.

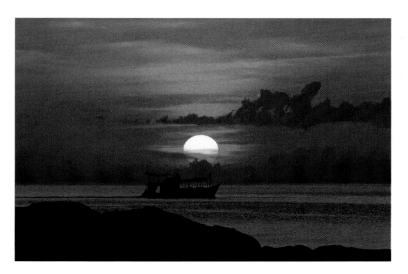

For the most part, I believe it comes down to cost. At one point early in my career I had to build my own website because I couldn't afford to have one professionally built for me that had a creative layout and sleek design. If an aspiring photographer has a problem affording a fairly simple website, how much do you think it costs to design and code an entire social network? Thousands? Well, it's more like millions! It is no wonder that massive online networks like Facebook and Flickr will then implement advanced compression algorithms to shrink the file size of your images once you've uploaded them to their servers. Not only does it save on space, it saves money too.

Google seems to have recognized the need for aesthetics. Google+ is simple yet sleek, beautiful yet refined, and most important, it displays your photographs beautifully.

The Seamless Layout and Design of Google+

From the moment you sign up with Google+, you'll notice the beautiful yet simple white background, the seamless navigation bar floating at the top of the screen, and the lack of harsh contrasting lines that separate the different sections of the website on any given page (**Figure 1.8**). Unlike Facebook or Flickr—where you sometimes have to jump through hoops to take advantage of a specific feature or change a setting—nearly everything you need in Google+ can easily be found on whichever page you are on.

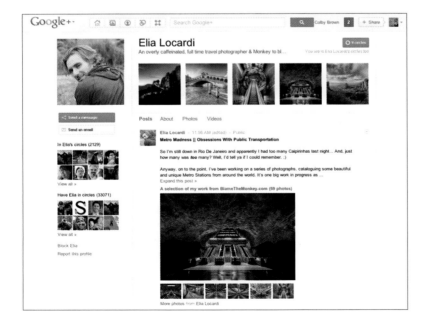

Figure 1.8 Your Google+ profile is sleek and clean. It allows you to creatively display your photography without that complex look and feel you find on other services.

The user interface has "polish" as well. When you begin to organize your Google+ circles on the Circles page, you'll find some very elegant animations that, even though they are small, add to the overall experience. When you navigate from profile to profile or from post to post, the action doesn't feel clunky or antiquated. All of these details may seem unimportant, but after you sit down for your first hour-long session with Google+, you will begin to appreciate these little nuances that make your experience more enjoyable.

How Google+ Displays Your Images

As photographers, we have enough to deal with as it is when it comes to having our images displayed accurately online. Because of the different types of computer monitors, various types of color profiles for images, and the multitude of different web browser options, the last thing we need is to have to worry about how our images display on the online networks we utilize.

Colby's Quick Tips

In Chapter 6 I cover the best practices for uploading your images to ensure that they look as good as possible.

With Google+, you have nothing to worry about. Clicking the Photos page (**Figure 1.9**) gives you a never-ending stream of beautiful image thumbnails from those in your circles in their original image ratios—no cropping and no distortion.

Figure 1.9 The Photos page on Google+ offers an endless stream of beautiful photos from those you have connected with.

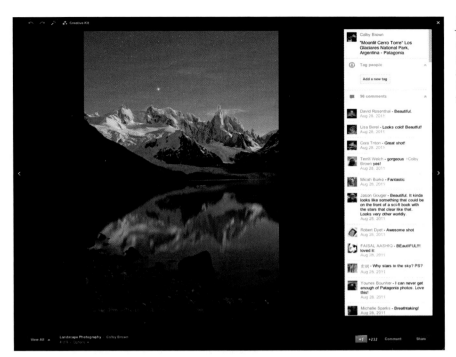

Figure 1.10
The lightbox in Google+ has a black background, allowing your images to jump off the page.

To check out an image in more detail, simply click a thumbnail and a beautiful black lightbox opens (**Figure 1.10**), allowing you to view a much larger version of the selected image and see all of the comments and +1s that the photo has received. As with the rest of Google+, here too you will find all the necessary tools to interact with the artist, tag people in the image, share the image with others, and much more. Did I mention that Google+ even offers a fairly advanced set of photo editing tools to do quick corrections to your images on the fly? It does, and I'll cover that in Chapter 7.

Google+ takes all of the worry out of displaying your beautiful images so you can concentrate on interacting with other users.

Photographers' Rights

When it comes to uploading your photography work to any website on the Internet, you should be aware of the benefits and potential pitfalls that might lie ahead for you. Although there is great benefit to having an online presence and sharing your photography work and skills with the world, you

Figure 1.11
Google's TOS
agreement can be
read in its entirety
at www.google.
com/accounts/b/0/
TOS.

also open yourself up to theft, copyright infringement, and occasionally, a complete loss of the rights to your images. People rarely pay attention to the fine print when entering a photography contest or joining an online network, but it is better late than never!

Clarifying Google's TOS Agreement

Before you decide to sign up for any online network or service, you should first read the fine print. This is found in the TOS (Terms of Service) Agreement (**Figure 1.11**). It is within this typically lengthy, mundane, and boring document that you will find all the juicy details that you absolutely should know before you do anything else.

When Google+ was launched on June 28, 2011, a very well-known professional photographer pulled specific lines of the Google+ TOS out of context and wrote a blog post warning the world about image rights and Google+, which was later picked up by the *Washington Post*. However, in standard fashion, it wasn't so much the specific lines he pulled from the agreement that were important, it was what he omitted.

Stated in his blog post were the following lines of the Google+ TOS:

- "By submitting, posting or displaying the content you give Google a perpetual, irrevocable, worldwide, royalty-free, and non-exclusive license to reproduce, adapt, modify, translate, publish, publicly perform, publicly display and distribute any Content which you submit, post or display on or through, the Services."

- "You agree that this license includes a right for Google to make such Content available to other companies, organizations or individuals with whom Google has relationships for the provision of syndicated services, and to use such Content in connection with the provision of those services."

- "You understand that Google, in performing the required technical steps to provide the Services to our users, may (a) transmit or distribute your Content over various public networks and in various media; and (b) make such changes to your Content as are necessary to conform and adapt that Content to the technical requirements of connecting networks, devices, services or media. You agree that this license shall permit Google to take these actions."

Now, if you read only those lines of the agreement, it might at first glance look like Google was taking the rights to your images, selling them to other companies, and laughing all the way to the bank. However, when you add these other two lines of the TOS agreement, the story changes:

- "11.1 You retain copyright and any other rights you already hold in Content which you submit, post or display on or through, the Services (for remainder see #3 below)."

- "This license is for the sole purpose of enabling Google to display, distribute and promote the Services and may be revoked for certain Services as defined in the Additional Terms of those Services."

To accurately display your images, share your content, and generally connect with others on Google+, Google must first be given permission. When it comes to photographs or graphic art specifically, Google resizes your images so that they display correctly on every type and size of computer monitor worldwide. It is comforting to know that my photography work will display accurately no matter if someone is using a smart phone or a $2000 professional IPS computer monitor.

Retaining Metadata with Your Images

As a photographer, it is important to protect your images from theft and copyright infringement. Although some photographers take this to the extreme and hide all of their work from the world, others are more sensible. The United States has pretty strict rules about copyright infringement but arguably even stricter guidelines for proving copyright ownership. Even though registering your images with the U.S. Copyright Office is single-handedly the best way to protect your images, embedding your copyright information into the image metadata is important as well (**Figure 1.12**).

Colby's Quick Tips

Registering your photography work with the U.S. Copyright Office (for U.S. residents) is not only a very important step in protecting your images, but it is a rather painless process. Currently, you can register as many images as you can upload in an hour for less than $35. Visit www.copyright.gov for more information.

So what is *metadata* you ask? By definition it is "Data that provides information about other data," according to the *Merriam-Webster Dictionary*. As it relates to photographs, metadata is data about the image, the artist, and any pertinent copyright information that is actually embedded on the image itself. Although your camera will automatically store information about your photograph (camera model, exposure settings, time the image was taken), you have to manually add all artist and copyright information during the importing or post-processing phase of your workflow. Many of the more popular image-editing and organizing applications can do this for you automatically every time you import an image from your camera to your computer. Adobe Lightroom, Adobe Bridge, and Apple Aperture are three of the most common applications.

Figure 1.12 Your metadata is preserved in Google+, allowing you to showcase your copyright for an image, as well as all of the data about how you captured the image.

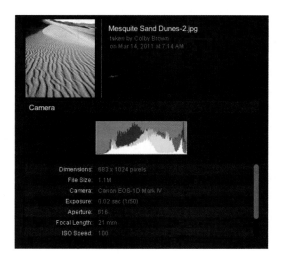

By maintaining accurate information in your metadata, specifically artist and copyright information, you are providing a legitimate way to showcase that you own the rights to your images. This is important in a situation of copyright infringement because it not only proves that you are the original copyright holder, but that you provided all the necessary copyright information. How does this pertain to Google+? Google+ maintains all metadata, whereas many websites on the Internet will strip the metadata from images once they are uploaded into their systems. Chapter 6 covers more on this subject.

Google's Hands-on Approach

For a company as large as Google, it is amazing how involved it is with its products. Last time I checked, Flickr employees weren't providing real-time customer support or interacting with its members proactively. I can't remember ever seeing a Facebook employee comment on a user's post or show users how to correctly utilize a function of the Facebook network. And I certainly don't recall ever seeing employees from any other online network showing up for local photography events or helping to organize them for their local communities. Do you ever wish the feedback you sent to a company actually held some weight? Google has you covered. That's right; not only are Google+ employees incredibly active and helpful on Google+, but many of them are photographers as well. So how does Google+ truly separate itself from the fold? Google hires full-time customer service representatives called *community managers*, promotes employee interaction across all of its products, and truly listens to customer feedback.

Google+ Community Managers

Google+ offers its users access to community managers. Think of Google+ community managers as full-time, hands-on, interactive product or service representatives. Why? Because that is what they are. The role of a community manager is to respond to questions, listen to feedback, engage with users, share interesting content, and provide weekly Google+

Dave Cohen:
A Photographer's Perspective

I grew up on the east coast and graduated with a degree in computer science from the University of Maryland. In 2005 I moved out to California after accepting an offer from Google and worked on Gmail for a number of years before helping to start the Google+ Photos team. When I'm not working, I'm usually out mountain biking, snowboarding, or taking photos.

Google+: *https://plus.google.com/116040565882702717981.*

Q What is your job title at Google? What exactly do you do?

I'm a technical lead on Google+ Photos, which means I do a little bit of everything—from technical design to writing code, product management, and interacting with our users. I'm also an avid photographer, and I bring that perspective to the table when we design new features.

Q In a nutshell, what is Google+?

Google+ is a project that aims to make sharing on the Web more like sharing in the real world.

Q Why does it feel as though Google+ was built for photographers?

Making sure Google+ had a great photos experience was one of our goals from the very beginning. From the stream to the lightbox to the album pages, we've worked hard to create a product where big, beautiful photos take a starring role. There's so much power in photographs; they convey emotions, tell stories, and, ultimately, connect people, which is what Google+ is all about. We work hard every day to continue improving this experience to make sharing photos in Google+ easier, faster, and more fun.

Q You are into photography, correct? Why do so many Google employees seem to love this art form?

I love photography because it gives me the freedom to reimagine the world around me. The more I get into it, the more I begin to notice all the little details in my surroundings that I might have otherwise rushed right past. The camera gives you so much freedom to take these details

and compose them in an infinite number of possibilities: For instance, the camera allows you to decide on the focal length you want, the depth of field, and what your focus will be. Even when I don't have my camera with me, I find myself framing shots in my mind.

I think many Googlers love photography for the same reasons. Google is full of incredibly smart, creative, detail-oriented people. Photography gives you an outlet where you can really put in as much or as little time as you'd like to get that shot just right. Plus, we're happy just to get out from behind our computers every once in a while!

Q What would your number one piece of advice be to a new photographer signing up for Google+?

One of the unique aspects of Google+ is that it has an amazing photographer community. A phenomenal number of hobbyists and pros post photos, share tips, and answer questions. If you're a photographer who's just getting into Google+, one of the first things you should do is create a Photographers circle and start following all the great photographers you come across. You might also be able to find a "shared circle" where someone else has already done the hard work for you! It's inspiring to see my stream full of gorgeous photos every day.

The Constant Evolution of Google+

Google+ was established on June 28, 2011. Within the first six months of its existence, well over 100 updates and improvements were made to the network, many of which were significant. As Google continues to listen to customer feedback while expanding Google+ according to its own plans for the network, potential users and current users can't help but get excited about the possibilities for the future. One thing is for certain: Google is investing its heart and soul into Google+ and has plans to bring all of its products and services into the network (**Figure 1.13**). Through this expansion is an amazing opportunity to build your photography business, get more eyes on your photography work, and connect with other photographers in ways you never could before. It is an exciting time to be a photographer in the digital age.

g+ +Colby	31 Calendar	Blogger
Search	Translate	Reader
Images	Mobile	Finance
Maps	Books	Photos
YouTube	Music	Videos
News	Offers	
Gmail	Wallet	
Documents	Shopping	
More	Even more	

Figure 1.13 An extensive list of all of the Google products that will eventually find their way into Google+.

community reports to the product and engineering teams that reflect the most up-to-date information about the network as possible. You can send them private messages, engage with them in posts, and even talk with them in person during a Google+ hangout.

Although Google as a whole has multiple community managers for a wide variety of its different products, you will find four directly affiliated with Google+ (**Figure 1.14**):

- **Natalie Villalobos.** Community manager for Google+
- **Toby Stein.** Community manager for Google+ Mobile
- **Katherine Gramann.** Community manager for Google+ Hangouts and Chat
- **Brian Rose.** Community manager for Google+ Photos

Figure 1.14 The four Google+ community managers.

By connecting with these Google employees on Google+, you will have a direct line of communication with the teams that built and continue to update Google+ on a daily basis.

Employee Interaction

Even though Google has multiple full-time community managers dedicated to different facets of Google+, it still encourages its employees to be as active as possible on the network. And I am not talking about just low-level employees. At any given time you can talk with someone working on Google Maps, connect to an engineer working on Android, or even have Google's Senior Vice President Vic Gundotra jump in a hangout with you. This truly gives you what feels like behind-the-scenes access to all things Google, which is something no other company of this size seems willing to do.

As mentioned earlier, many of Google's employees, including those working on the Google+ Photos team, are actually photographers. They share their own images, talk about the camera gear they love, and are happy to help promote other photographers (**Figure 1.15**). But in customary Google fashion, their interaction doesn't stop there.

Figure 1.15 Brian Rose, the community manager for the Google+ Photos team is always promoting photo walks hosted by other Google+ members.

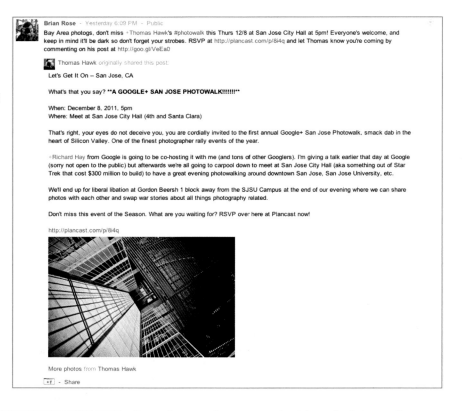

Brian Rose · Yesterday 6:09 PM · Public

Bay Area photogs, don't miss +Thomas Hawk's #photowalk this Thurs 12/8 at San Jose City Hall at 5pm! Everyone's welcome, and keep in mind it'll be dark so don't forget your strobes. RSVP at http://plancast.com/p/8i4q and let Thomas know you're coming by commenting on his post at http://goo.gl/VeEa0

Thomas Hawk originally shared this post:

Let's Get It On — San Jose, CA

What's that you say? **A GOOGLE+ SAN JOSE PHOTOWALK!!!!!!!**

When: December 8, 2011, 5pm
Where: Meet at San Jose City Hall (4th and Santa Clara)

That's right, your eyes do not deceive you, you are cordially invited to the first annual Google+ San Jose Photowalk, smack dab in the heart of Silicon Valley. One of the finest photographer rally events of the year.

+Richard Hay from Google is going to be co-hosting it with me (and tons of other Googlers). I'm giving a talk earlier that day at Google (sorry not open to the public) but afterwards we're all going to carpool down to meet at San Jose City Hall (aka something out of Star Trek that cost $300 million to build) to have a great evening photowalking around downtown San Jose, San Jose University, etc.

We'll end up for liberal libation at Gordon Beersh 1 block away from the SJSU Campus at the end of our evening where we can share photos with each other and swap war stories about all things photography related.

Don't miss this event of the Season. What are you waiting for? RSVP over here at Plancast now!

http://plancast.com/p/8i4q

More photos from Thomas Hawk

+1 · Share

Over the past few years, the idea of *photo walks*, a casual gathering of photography enthusiasts of all levels, has become incredibly popular. The general idea is that you get together a group of individuals interested in photography to meet in a specified location and walk around taking photos. This past year I've seen them pop up in San Francisco, Denver, Seattle, New York, London, Sydney, and even Death Valley National Park (**Figure 1.16**). Since the launch of Google+, not only have Google employees shown up at these events, but they've promoted and often helped organize them as well. These events offer great opportunities to network with fellow local photographers, work with full-time working professionals, and occasionally get to meet some of the very people who help design, build, and code many of the Google products you use.

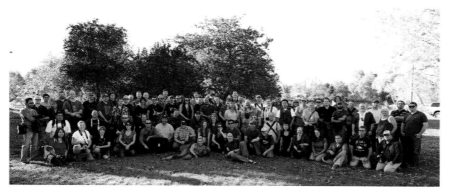

Figure 1.16
A Google+ sponsored photo walk that I hosted in Denver, Colorado. Over 80 photographers showed up for the event.

The Power of User Feedback

Most companies ask for feedback on the products they offer or the services they provide, but it typically feels like a disconnected process. You fill out an online form, click Send, and then patiently wait for something, anything, to happen. Google+ offers a slightly different experience. In fact, Google+ updates and even adds new features often based on user feedback. If enough people send in a feedback request for a specific problem or desired feature (**Figure 1.17**), Google gives it a high priority on its to-do list. It is quite different to actually see some of the features you personally asked for appear on the network. The entire process gives you the feeling that you are part of this network and that your voice matters, which are the reasons that make Google+ users feel right at home.

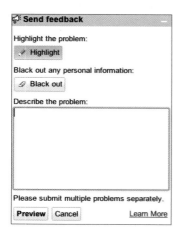

Figure 1.17 The feedback button is located at the bottom left of every page on Google+. The box that opens allows you to highlight problems as well as black out any personal information you do not want to share.

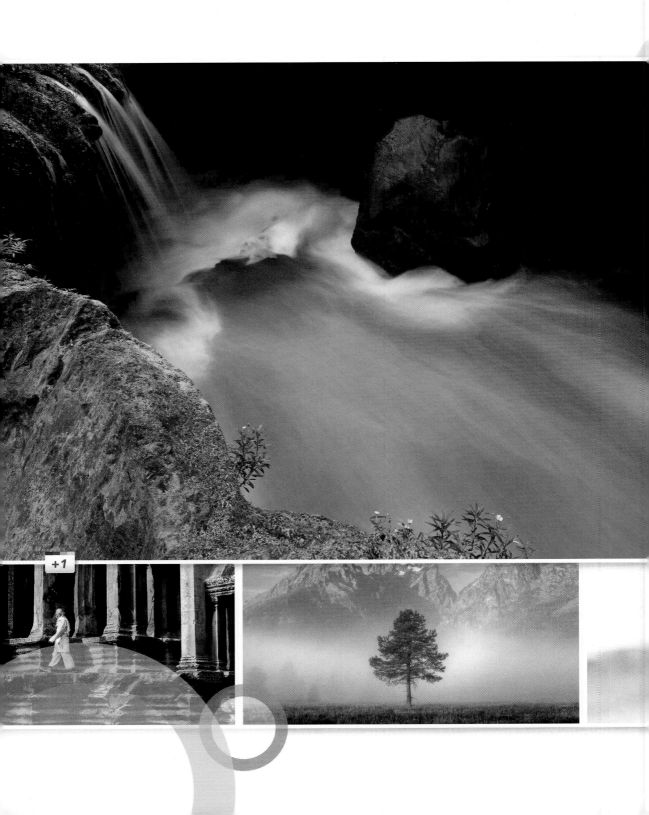

+1

Building an Online Presence

In this digital age, it is impossible to ignore the benefits of the Internet. As family members, you share photos and keep in touch over long distances. As consumers, you research and purchase products that fit your needs. And whether you are just getting into photography or you are a seasoned professional, there is no doubt that the role of the Internet in your lives has changed not only the way you approach photography, but the way you interact with others as well.

With the increasing popularity of online networks over the last 12 years, photographers and other artists alike have the ability to share their passions and creations with the world unlike ever before. However, when people first sign up with any of these online networks, they have no idea how to start building a following or establishing a name for themselves.

In this chapter I'll walk you through a few fundamental aspects of building a brand, such as the value of consistency and being yourself. I'll also talk about social marketing and the importance of having the right mind-set as you plan and carry out your own networking strategy.

Creating a Photography Brand

With the advances of technology from within the photo industry, which has motivated more and more individuals to take photographs, and the growing popularity of using online networks to expand businesses, you must work hard to separate yourself from the fold. Google+ has a very large and growing photography community calling the network home. This means that many photographers are vying to have their voices heard and their images viewed (**Figure 2.1**).

Although producing phenomenal photography work is part of the answer, it is really just the beginning. You can visit websites like www.500px.com and www.1x.com to look at amazing images from artists you've never heard of and possibly never will again. To take your business to the next level, you need to create a photography brand. By definition, a brand is a trademark or distinctive name identifying a product or a manufacturer.

Figure 2.1 In the first five months of Google+'s existence, people shared over 3.4 billion images on the network.

The idea is to make your photography work, your company, and who you are memorable. Trey Ratcliff is a perfect example of someone who has successfully developed his brand. It is difficult to look at any HDR (High Dynamic Range) photograph and not think of www.StuckinCustoms.com (**Figure 2.2**), which is Trey's website and blog. It doesn't matter if you prefer HDR photography or not, because you have already made the connection between his business and a genre of photography in your mind. This is exactly what nearly all those who want to make a living as a photographer should strive for.

Content Is King

When it comes to building your own photography brand, the content you publish and share online is the first building block. One of the biggest mistakes photographers of all different calibers make is not realizing that they are doing the same thing as everyone else. Most photographers jump into an online network or start a new website, share a couple of photographs, and then get upset when no one engages with them (**Figure 2.3**). Because of the sheer size of a network like Google+, or the Internet for that matter, one of the most difficult challenges to overcome is being lost in the noise of content already being shared.

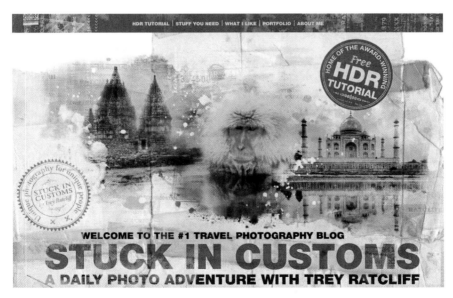

Figure 2.2 Stuck in Customs is professional photographer Trey Ratcliff's website and blog. It is one of the most trafficked travel and photography blogs on the Internet.

Figure 2.3 The lack of interaction with something you post online is very often because people don't even know you published it. With so much information flowing through the Internet at any given moment, you must go the extra mile to encourage engagement.

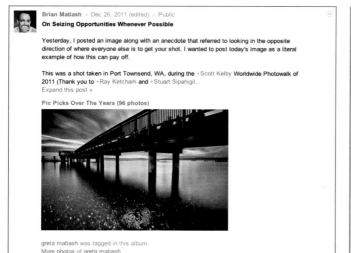

Brian Matiash - Dec 26, 2011 (edited) - Public
On Seizing Opportunities Whenever Possible

Yesterday, I posted an image along with an anecdote that referred to looking in the opposite direction of where everyone else is to get your shot. I wanted to post today's image as a literal example of how this can pay off.

This was a shot taken in Port Townsend, WA, during the +Scott Kelby Worldwide Photowalk of 2011 (Thank you to +Ray Ketcham and +Stuart Sipahigil...
Expand this post »

Pic Picks Over The Years (96 photos)

greta matiash was tagged in this album.
More photos of greta matiash

Trey Ratcliff originally shared this post:
Why I Don't Use Watermarks

I get this question a lot, and I know it came up in the live hangout last night. I know my opinion is different than many other photographers, and that is okay.

As you may know, my work is all Creative Commons Non-Commercial. That means people, as long as they give credit and link back to http://www.StuckInCustoms.com , can use my images on their blogs, wallpaper, personal ...
Expand this post »

Portfolio - The Counter-Earth, the one some of us see... (492 photos)

Figure 2.4 Brian Matiash is a photographer from Portland, Oregon, who is known for his in-depth and detailed stories of his photographs and passion for the art form. He experiences high levels of interaction on the content he publishes because he has a unique perspective that allows his followers to be engaged by his images as well as his stories.

Figure 2.5 This post by Trey Ratcliff was shared throughout the Internet thousands of times, not only because he has built up a large following through various online social networks, but because the topic of his post was interesting and he brought with it a fresh perspective that works for him.

Creative and original content

Although your first and best instinct is to start sharing images that you feel best represent you as a photographer, you have to do more than that. Instead of just sharing one of your images, also share the story behind what it took to capture your photograph (**Figure 2.4**). If there is a topic that you have a fresh opinion on, write out a well-thought-out piece and share it with your followers (**Figure 2.5**). Discuss photography-related news and announcements based on your experiences as a photographer. Your average viewer has a very short attention span, and no matter how beautiful a single image is on its own, often it is not enough to get a viewer to constantly come back to you looking for more.

Consistency in your message

Another difficult challenge of maintaining an online presence for any individual or business is consistency. Building a following takes time, energy, and effort to stay on cue. It is important to maintain a level of consistency throughout your presence online. This doesn't mean that you should only

Figure 2.6 My accessibility to others allows me to maintain high levels of interaction and engagement with nearly everything I publish to Google+.

share your genre of photography, such as black and white photographs. If your followers are used to you providing the story behind your images when you publish them, that is something you'll need to keep up with.

Maintaining a consistent tone and feeling about your work, your level of engagement with other users, or the content you share or publish allows your followers to feel comfortable, and they'll depend on you for the things you are known for.

Ever since Google+ launched, I've made myself as accessible as possible to other Google+ users so they could ask me questions regarding the network, photo gear, my photography workshops, or anything else that is on their mind. Although it is very time-consuming to respond to hundreds of emails and tags on Google+ each week, it has allowed me to build up a reputation as a very approachable professional photographer and power user on the network (**Figure 2.6**).

Focusing on Others

As we venture further and further into the Internet/digital age, people are becoming savvier when it comes to recognizing marketing pitches or individuals and businesses that focus only on themselves. This is exemplified when these practices emerge in a network such as Google+, which contains many different communities that focus on interests, such as photography. I constantly come across incredibly talented professional photographers who are struggling to build a following because they are purely focusing on themselves and the products or services they offer. Why? Because people can read through the lines.

If you look at many of the most followed photographers on Google+, they have a few common threads. Although they do share quality images with their followers, they also freely share their knowledge of photography, are willing to answer questions and engage with their followers, and are constantly helping other photographers get some recognition by sharing

Sharing More About You

In the past it has been common practice for individuals to separate their businesses and personal lives. To this day, I see photographers creating separate online accounts for their businesses rather than consolidating everything into one. This is potentially an understandable strategy in many business markets, but for photographers, this misses the point of letting your followers actually get to know you.

As a photographer, my passion is to document life on this planet. I am also, however, a firm believer in the idea that my experiences have a direct effect on the way I view the world. This means that external factors, such as my family and my other interests outside of the photo industry, do play a role in the images I capture around the globe. By sharing information about me (**Figure 2.7**) or content that I find interesting that is not related to my photography businesses, I give my followers a deeper understanding of who I am as a person and what drives me to be the kind of photographer I am. People love the story behind the story, and contrary to what you might have learned in Business 101 classes in college, allowing your followers, clients, and customers to have the opportunity to understand you a little bit better will pay off in spades for your business and online presence.

Note that I do still refrain from engaging in or bringing up discussions on civil, religious, or political matters to anyone outside of my close friends and family because of the polarizing nature of the topics.

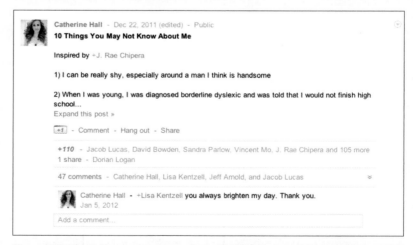

Catherine Hall - Dec 22, 2011 (edited) - Public
10 Things You May Not Know About Me

Inspired by +J. Rae Chipera

1) I can be really shy, especially around a man I think is handsome

2) When I was young, I was diagnosed borderline dyslexic and was told that I would not finish high school...
Expand this post »

+1 - Comment - Hang out - Share

+110 - Jacob Lucas, David Bowden, Sandra Parlow, Vincent Mo, J. Rae Chipera and 105 more
1 share - Dorian Logan

47 comments - Catherine Hall, Lisa Kentzell, Jeff Arnold, and Jacob Lucas

Catherine Hall - +Lisa Kentzell **you always brighten my day. Thank you.**
Jan 5, 2012

Add a comment...

Figure 2.7 Much like many other well-established photographers, Catherine Hall makes a point of sharing more than just her images with her followers. By letting people get to know her as a person as well as an artist, she helps to break down the walls and distance commonly found when connecting with individuals over the Internet.

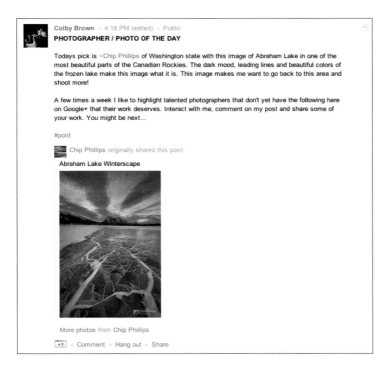

Figure 2.8 This image by photographer Chip Phillips of Washington caught my eye as I was browsing through Google+. My following is nearly 200 times larger than Chip's, so by sharing his beautiful image with my followers, he has the ability to reach a much wider audience and gain more of a following on the network.

the content they publish or including them in circles they share with their massive followings (Chapter 4). One of my favorite practices on Google+ is publishing my Photographer of the Day selection (**Figure 2.8**). A few times a week I'll search Google+ to find talented photographers who have either just joined or are having a hard time building a following. By sharing one of their images that I admire, I help their work reach a much broader and larger audience. I'm certainly not the only photographer on Google+ to do this and in fact have found and followed many great artists through other users' selections.

Engage, Engage, Engage

As mentioned previously, a common misconception of many photographers on any online network is that the quality of their work alone is enough to magically garner a following. Those who follow this train of thought forget the "social" aspect of social networking. Keep in mind that when you publish anything online, you are in effect competing for viewer attention with everyone else. Users can only view so much content coming at them and often miss content they would have interacted with if they

knew it existed in the first place. For example, if users do not see the content you publish because they are away from their computer, how can you expect them to interact with it?

One of the best ways for you to begin to build an online presence and let people know you exist is to engage with other users. Commenting on posts or photos and engaging in conversations with other users gets you noticed on the network. In fact, you could use Google+ Hangouts (Chapter 8) to easily videoconference with up to nine other Google+ users from all over the world, which brings a whole new personal level of engagement to an online network.

After you have uploaded one of your images or made a post to Google+, don't forget to stick around and engage with those who interact with you (**Figure 2.9**). A common response I receive from the emails or private messages sent to me is surprise that I responded at all. Many photographers are not willing to take the time to engage with others, even though the rewards speak for themselves. My personal networking philosophy is that you never know what opportunities can present themselves through connecting with another individual, so treat everyone like gold.

Figure 2.9 Varina Patel and her husband, Jay, both professional photographers, are known for their willingness to engage with their followers. Not only do they share tips and tricks when it comes to helping others improve their photography skills, but they respond to and engage with those who comment on their photos and posts.

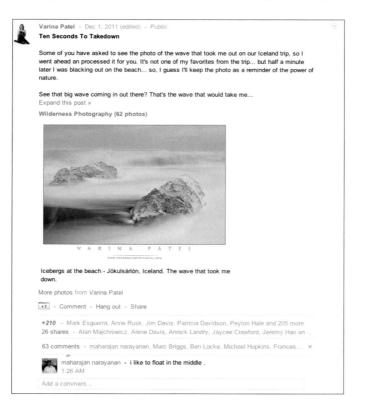

Principles of Social Marketing for Photographers

It is not entirely surprising that many photographers have a difficult time understanding various principles of social marketing. After all, the creative right side of the brain typically doesn't handle concepts tied to business practices, which are usually very analytical in nature. Regardless, social marketing is a fundamental aspect of running a photography business, building a brand, and establishing yourself in the photo industry.

Quality over Quantity of Followers

It is very easy to get sucked into the notion that a social network is in a sense a popularity contest. On Google+ alone, there are hundreds of thousands of photographers, ranging from those just joining the network to those who have over 700,000 followers (**Figure 2.10**). Too often I see individuals more worried about how many followers they or the person next to them have rather than concentrating on building relationships with those who have chosen to connect with them.

A common practice on every online network is to offer a product giveaway to get more users to follow you, sign up for your blog, or connect with you in some way. The problem with this approach is that the users you are attracting are not necessarily connecting with you because they enjoy your photography work or the content you publish, but instead are most likely looking for a free handout. These contests certainly have the potential to pad your numbers but not much else.

Photographer		
TREY RATCLIFF	VERIFIED	730021 IN CIRCLES
THOMAS HAWK	VERIFIED	720126 IN CIRCLES
LISA BETTANY	VERIFIED	480696 IN CIRCLES
ELENA KALIS	VERIFIED	418627 IN CIRCLES
COLBY BROWN	VERIFIED	387385 IN CIRCLES
LOTUS CARROLL	VERIFIED	387191 IN CIRCLES
PATRICK DI FRUSCIA	VERIFIED	374919 IN CIRCLES

Figure 2.10 This is a list of the seven most followed photographers on Google+ according to the Group/As website (www.group.as). Although these numbers might look impressive at first glance, the reality is that only a portion of the followers are actively engaging with these photographers. Numbers can be deceptive.

When developing your own social marketing strategy, you want to focus on gaining quality followers, not obsess about quantity. This is not to say that numbers cannot have an effect on your business, but simply that you get much less benefit from a user who does not engage with the content you publish than from a user who does. If you concentrate on building relationships, publishing original content, and expanding your own body of photography work, the people will come, and more important, they will be the users you want to connect with.

Planning Ahead

As a landscape and travel photographer, I'm meticulous when it comes to researching and planning for my photography trips. When visiting a country like Nepal, I'll spend months studying the locations I'll be documenting, reading books that discuss Nepalese culture, and researching transportation, lodging, and local customs. When it comes to developing a social marketing strategy, you should put the same amount of thought into planning ahead.

With the content I publish on my blog or through the various online networks that I frequent, such as Google+, I am constantly thinking five steps ahead. I'm constantly thinking about choosing what articles to write, which images to share, and the best time to publish all of this content. Because social networks consist of various types of individuals from all over the world, it is important to take your audience into account when you are developing your social marketing strategy. Do most of your followers live in Europe? The East Coast of the United States? Australia? Are they professional photographers? Amateurs? Do you want to only reach your past clients or attempt to sell your prints to new customers? The answers to these questions should help you formulate a plan for deciding when to publish the content you want to share so that your followers actually see the post and how to word your posts to reach the right audience (**Figure 2.11**).

The bottom line is that there is no one right answer or magical equation when it comes to developing a solid social marketing or business strategy. Every photographer is different, and everyone's clients are different (for the most part). You have to find out what works for you, your clients, and your followers, and then plan accordingly.

Sticking to Your Business Strategy

Another common mistake made on online networks is caring way too much about what other photographers think of your work. Most online networks for photographers are relatively focused on the art of photography, which means you'll mostly be surrounded by other photographers. Instead of

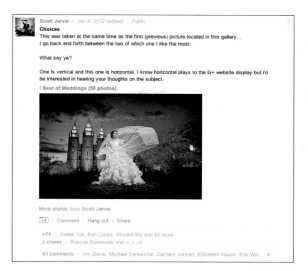

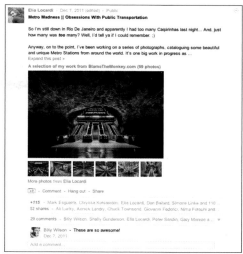

Figure 2.11 Scott Jarvie is one of the top wedding photographers in the United States and is based in Utah. Because many of his clients live in Europe, Scott is known for posting at all hours of the day to make sure his work and the content he publishes is seen by those in other time zones.

Figure 2.12 Elia Locardi produces some of the most detailed and amazing HDR images in the photo industry. Although not all photographers might appreciate his style, his clients and customers who license his images for magazines, billboards, and various ads around the world are beyond happy with his work.

focusing on building a portfolio and advancing your photographic skills, you choose to concern yourself with how many comments a photo you posted received or if a certain photographer liked your work. However, unless you are a photo educator or instructor, your customers or clients are rarely other photographers. Because art is so subjective, requiring the admiration of other photographers is not required in order for you to grow as an artist and for your business to flourish.

A perfect example is HDR photography (**Figure 2.12**). Within the photo industry, it is a very polarizing topic. Although some photographers enjoy expanding the dynamic range of their images, many have strong dislikes for HDR photography. Clients and customers who purchase prints, however, tend to love it. Ultimately, you need to follow your own business strategy when it comes to marketing to your clients and not focus on whether your colleagues appreciate everything you publish.

There is a difference between focusing on how many people +1 your images on Google+ and networking or learning from other photographers. One is built to serve your ego and the other to better you as a photographer and help build your business. The challenge is to identify the reasons you are on an online network in the first place, and then develop and stick to a strategy to achieve your goals.

Brian Matiash:
A Photographer's Perspective

Brian Matiash is a published photographer, writer, and lover of all things social media. He is the curriculum and education manager at onOne Software, makers of the award-winning Perfect Photo Suite line of photography editing software. Originally from Brooklyn, New York, and now living in Portland, Oregon, Brian has made a name for himself as an authority on HDR photography and is known for his grungy Urban Exploration and ethereal long-exposure black and white landscape images.

Website: *http://brianmatiash.com/*

Google+: *http://brianmatiash.com/+*

Q In the digital age, how important is it to have an online presence as a photographer?

Having an online presence these days is a critical component to the success of a photographer, especially the emerging ones. There are a lot of moving parts that need to be considered in terms of what your brand should be and which images should be shared, but photographers have an unprecedented opportunity to broadcast their work and their brand to millions and millions of people. By being diligent and keeping up with the rigors of consistently maintaining your online presence, you can certainly open up doors in many unforeseen places.

Q In the business world, the word "branding" is commonly used. What does it mean, and why is it important for a photographer?

If you couple the words "branding" and "photographer," your brand would be the type of photography you excel in and that showcases your strengths in artistic vision and consistency. However, if you throw "online presence" into the mix, branding starts to take on a more complex flavor. Now, you have to consider how you present yourself in the online stratosphere. Are you jockeying to be an authority in a certain field? An inspiration provider? Or maybe you're just out to promote your business? Whatever it is, you need to be cognizant of being consistent in tone, in online presence, and most important, in being able to produce and share high-caliber images.

Q What are the common mistakes photographers make when entering a social network?

If I had to choose one pit that so many photographers fall into, it would be that they care too much about what other photographers in the online stratosphere think about their work. Instead of focusing on building and maintaining their brand, they are more concerned about the performance of an image (i.e., how many +1's, likes, comments, and so on it garners). Instead of spending time and mental energy on what other people think of your work, spend it going out and

getting new shots; building your body of work to share with the masses; and continuing to maintain, hone, and refine your brand online along with trying to establish new contacts in this industry.

Q What is the best piece of advice you could give someone who wants to build an online presence?

There are two pieces of advice that I have found to be key in my own success as a photographer with an online presence:

1. Share often and consistently. This can come to mean many things. Share your images—your best images. You have one shot at a first impression, so start off with what you consider to be your best work. If you need help pruning that down, reach out to a photographer who you admire and ask for help. Most photographers are happy to lend a helping hand.

2. Establish a posting frequency and stick to it. The public is very fickle. If you get people to a point where they expect to see a new offering from you every day or every other day, or once a week, STICK TO IT! You don't want to get in the habit of breaking expectations, especially if they are favorable ones.

3. Be yourself… the best of yourself. When you're posting online and trying to build your brand and identity, the best way you can do so is to simply be yourself. Sincerity flows so nicely when it is truly there. With that said, I also think that it doesn't hurt to treat your brand like a corporation. Whenever I post online, I always refrain from 'soapbox' opinions. I never opine about politics, religion, or rant about any particular person, group, or social issue. I also keep my language clean and do my best to put out educated and well-versed posts. I want people to feel comfortable and like they know me when they read my words, so consistency of tone within my posts is critical.

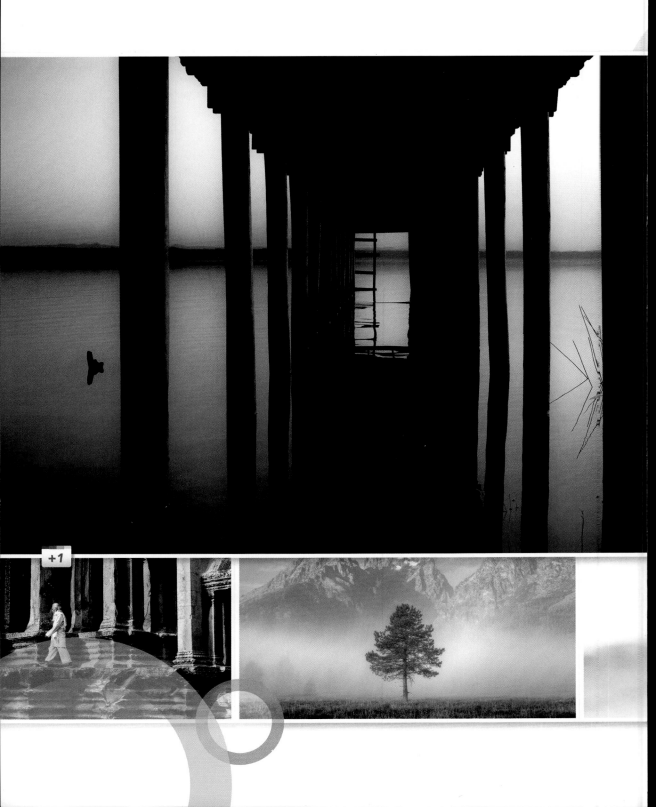

Getting Started with Google+

Now that you have an understanding of why the photography industry has quickly adopted the use of Google+, as well as a grasp on the challenges and benefits of having an online presence as a photographer, it's time to dive in and get started with Google+. As discussed in Chapter 2, it's important to develop an effective strategy when utilizing Google+ for your photography needs. Several choices are available to you to help you represent yourself and your photography work on Google+, and those choices begin as soon as you sign up.

In this chapter, I'll walk you through the sign-up process, help you fill out your user information and set up your profile, and clarify the differences between creating a user profile and a Google+ business page. After signing up, I'll explain the core features of Google+ and make sure you know how to adjust your Google+ settings to suit your needs.

Signing Up with Google+

As with any online network, the first order of business is to actually sign up. Throughout this process, Google walks you through a series of web pages to help you get your Google+ account up and running. When you visit the Google+ home page (http://plus.google.com), you will be greeted with a web page similar to the one shown in **Figure 3.1**.

To sign up for Google+, you must first have a Google account. With a Google account, you have access to Gmail, YouTube, Google Reader, Google Docs, Google Calendar, saved bookmarks with the Google Chrome browser, Google Books, and the Android Market.

To create a new Google account, click the "Create an account" link located just below the "Sign in" button on the Google+ home screen (**Figure 3.2**).

Figure 3.1 This is the page you will see when you visit the Google+ home page for the first time.

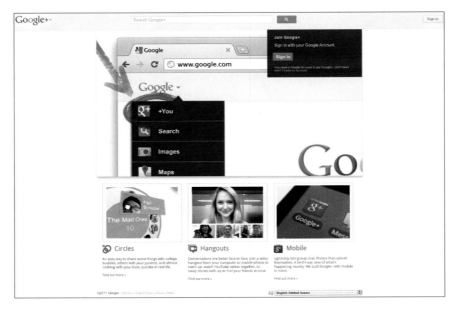

Figure 3.2 The "Create an account" link takes you to a new web page, allowing you to fill out all of the necessary information to get started with Google.

After setting up your Google account, you can revisit the Google+ home page at http://plus.google.com. Click the "Sign in" button to go to the Google+ login screen (**Figure 3.3**).

Enter your email (*Google account* + @gmail.com) and password, and click the "Sign in" button. You are then redirected to the Upgrade page (**Figure 3.4**). To join Google+, you must create a public Google profile, which means that you need to fill in your first and last name, select your gender, add an optional photo for your profile image, and select a check box stating that "Google may use my information to personalize content and ads on non-Google web sites." After completing the necessary steps, click the Upgrade button to continue.

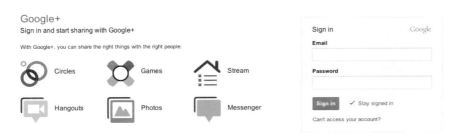

Figure 3.3 The Google+ login page displays the logos for the various features of Google+ and allows you to sign in to the network.

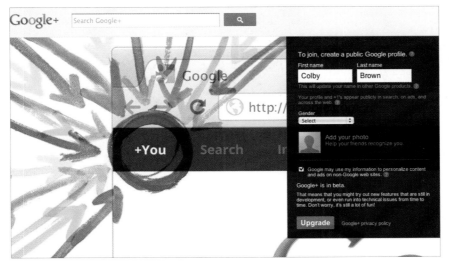

Figure 3.4 The Google+ Upgrade page might not be visible to users with established Google accounts prior to attempting to sign up with Google+.

Suggest Users You Might Know

The Suggestions page pops up next and asks if you want to add individuals to your Google+ circles (**Figure 3.5**). You can either type in the names of any Google+ users that you know, add any of the users that Google suggests to you, or scroll down the Suggestions page to connect to your Yahoo or Hotmail email accounts to look for users you already know.

On the right side of the screen, Google+ attempts to explain what a circle is. In short, circles are groupings of individuals who share a common bond. You can have a circle for family members, one for landscape photographers, another for past clients, and so on. By separating individuals into circles, you have full control over who you publish content to as well as what content you see from others on Google+. There is no limit to the number of circles you can create. For more in-depth information on circles, see Chapter 4.

When you are ready to continue, click the Continue button in the bottom-left corner.

Figure 3.5 The Suggestions page helps you connect with individuals that you might already know.

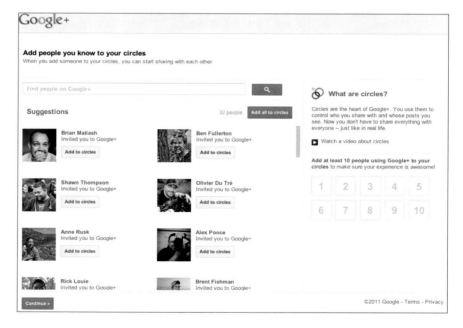

Google's Suggested User List

Next, Google takes you to its Suggested User List page (**Figure 3.6**). Google handpicks a selection of individuals who represent the various communities on Google+. You will find celebrities, musicians, journalists, tech writers, politicians, and even painters and photographers in their respective groups on this page.

To view the individuals in these groups, simply click the group you are interested in. As a photographer, you may be more compelled to circle someone in the Photography & Art section. After you click the desired group, a screen appears that showcases the individuals in the group in the left scrolling sidebar. Select one or more individuals to see their latest Google+ posts on the right (**Figure 3.7**).

If you want to circle everyone in the selected group, simply click the Add button in the top left of the screen. To only add a selected individual from within this window, click the gray "Add to circles" button in the top right of the page. To return, click the gray X in the right corner.

When you are ready to continue, click the Continue button on the main screen of the Suggested User List.

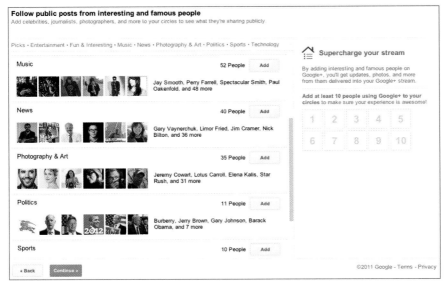

Figure 3.6 The Google+ Suggested User List provides you with a starting point for connecting with interesting people on Google+. The users have large followings, which means they provide more opportunity to find and interact with other individuals through the content they publish.

Figure 3.7 You can click various individuals in the group to view their most recent posts. This insight will give you an idea of the type of content they are providing to those who follow them.

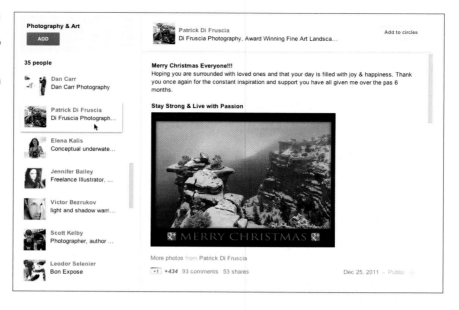

Figure 3.8 Filling out the information on this page is optional. You will have the opportunity to edit your entire Google+ profile from your Profile page.

Additional Profile Information

To complete your Google+ sign-up, the final page you'll see is the Additional Profile Information page (**Figure 3.8**). The information you fill out on this page is purely optional. Here you can let everyone know about your education, place of employment, and current location, as well as change your profile photo.

Click the Finish button when you are ready to complete the sign-up process.

Understanding Your Google+ Profile

Now that you've completed the sign-up process, it is time to complete your Google+ profile. Your profile is your home base on Google+. It gives you the opportunity to tell others about you and your photography work. Not only is it important to complete your profile so that it appears in search engine results, but also because it is your first opportunity to impress other Google+ users enough to start following you. To start, click the Profile icon located in the Google+ navigation bar at the top of your screen (**Figure 3.9**).

The first time you view your profile, a Welcome screen pops up asking you to fill out various profile fields (**Figure 3.10**). Although most of the fields are pretty straightforward, your Tagline and profile image are especially important. Google+ users without profile images have a very difficult time building a following. Because your Tagline is searchable through Google+ and the Internet, you should include as many relevant keywords as possible so that others can easily find you. For example, my Tagline reads, "Professional Fine Art Landscape, Travel and Humanitarian Photographer, Educator, and Author."

When you've finished filling out the profile fields, click the "Continue to my profile" button in the top right of the window.

Figure 3.9 The Profile icon is located in the middle of the icon set in the navigation bar. A silhouette of a person inside a circle represents your profile.

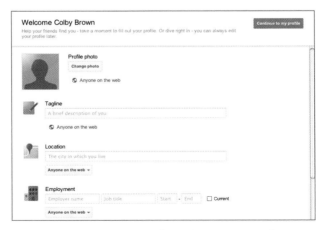

Figure 3.10 The Google+ profile Welcome screen only appears the first time you access your profile. It offers you the chance to easily fill in much of your profile from the start.

User Profiles vs. Google+ Pages

When it comes to having an online presence as a photographer on Google+, you have two options: maintain a personal user account or create a Google+ business page (**Figure 3.11**). A *page* is a Google+ account for an entity,

organization, group, or company. A page can act in a similar manner as a user account, but it does have some restrictions. Note that you are required to have a personal user account in order to create a business page.

Although Google+ Pages and user profiles have many similarities, there are a few key differences:

- Pages cannot add people to circles until the page has been added or tagged in a post by the user first.

- Pages can be created for a variety of different entities; profiles can only be created for a sole individual.

- Pages can have multiple administrators.

Figure 3.11 This Google+ page is for The Giving Lens, an organization I started that blends photo education and giving back to local communities. Having a Google+ page instead of a separate user account allows me to let my multiple employees administer and manage the page without using my personal user profile.

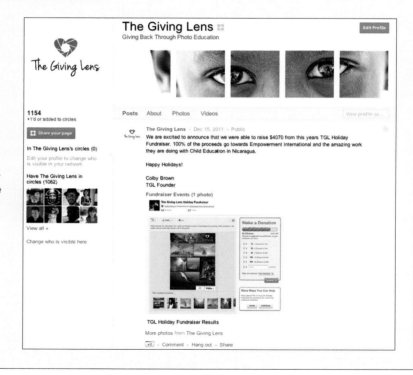

- You can add pages to your circles, just like a user account.

- The default privacy setting for information on your page profile is set to public.

- Pages contain the +1 button on the page profile, allowing you to increase your standing in search engine results.

- Pages cannot +1 other pages, nor can they +1 anything on the Internet.

- Pages can't utilize the Games section on Google+.

- Pages do not have the option of sharing content to Extended Circles (Chapter 4).

- Pages cannot start or join a hangout on a mobile device, but they can create a hangout and invite their followers on Google+ from a web browser.

To create a Google+ page, follow these steps.

1. Click the Google+ Pages icon, which is found on your Google+ home screen as well as on any other Google+ page.

2. Select the kind of business page you want to create (**Figure 3.12**).

3. Name the page you want to create, add the website (optional) you want it to be affiliated with, and fill in the "content appropriate" box before agreeing to the terms of service.

4. Click Create.

Create a page

Pick a category

- Local Business or Place
- Product or Brand
- Company, Institution or Organization
- Arts, Entertainment or Sports
- Other

Add your info

Other

Page name

Website (optional)

Your page will be publicly visible. Its content is appropriate for

Any Google+ user

☐ I agree to the Pages Terms and I am authorized to create this page.

CREATE

Figure 3.12 When creating a business page specifically for a photography business, I recommend that you choose the Other category. A Photographer category is not available within any of the other choices.

Profile Privacy Control

As with many of the Google+ features, you have complete control when it comes to deciding who can view the information you want to add to your Google+ profile. When you are in editing mode (by clicking the Edit Profile button in the top-right corner of your profile), you'll notice a gray icon that looks like a globe next to many sections of your profile (**Figure 3.13**). This icon indicates that you can control the visibility of those sections to other Google+ users and anyone viewing your profile from the Internet.

If you click one of the gray icons, a window appears that contains the "Anyone on the web" button (**Figure 3.14**). When you click the button, a menu appears with the following options (**Figure 3.15**):

- **Anyone on the web.** Anyone on the Web can view the information, not just individuals on Google+.

- **Extended circles.** Those you have in your circles and those in their circles can view the information. This is explained more fully in Chapter 4.

- **Your circles.** Everyone you have added to your Google+ circles can view the information.

Figure 3.13 The gray globe icons on nearly every section of your Google+ profile indicate that you can control the visibility of those sections to other Google+ users.

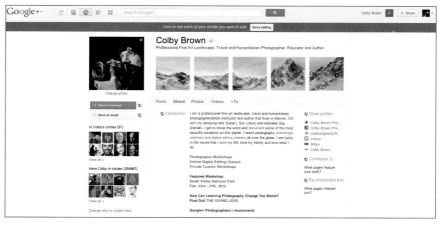

Figure 3.14 The "Anyone on the web" button is found throughout your Google+ profile.

Figure 3.15 This menu allows you to have full control over the visibility of the content in question.

- **Only you.** Private. Only you can view the information.
- **Custom.** You can select a few Google+ users, just two of your circles, or any other endless combination of people you have connected with on Google+ to view the information.

Profile Layout

After you have completed filling in the fields in the initial window, click the "Continue to my profile" button to be directed to your profile (**Figure 3.16**). Many different aspects and features of your Google+ profile are worth becoming familiar with. So click the Edit Profile button in the top-right corner, and let's walk through your Google+ profile.

Profile image

Your Google+ profile image represents the thumbnail that all other Google users view first when connecting with you. Therefore, it's important to select an image that represents you as a photographer. Although you certainly could use either your photography business logo or one of your best images, I recommend using your photo (**Figure 3.17**). As mentioned in Chapter 2, blending the image of your business to represent you and your photography work allows you to offer much more depth and character.

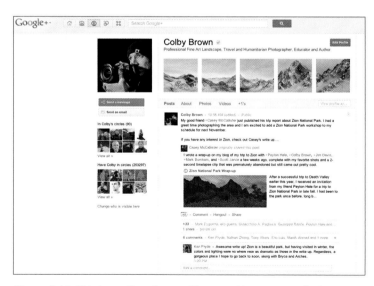

Figure 3.17 This is the image that I use as my Google+ profile photo. Not only does it give the viewer a chance to see my face (or most of it), but it shows one of my professional camera bodies in the frame as well. The idea is to inform viewers that I am a photographer.

Figure 3.16 This is my Google+ profile page. Here you can find out more about who I am, my photography work, and the content I publish on Google+.

By also including a camera in your photo, you automatically indicate to viewers that you are interested in photography.

To change your profile photo, click the "Change photo" link below the profile image. In the "Select profile photo" window that appears, you can upload a new photo, use another image you have already uploaded, use an image that you have been tagged in from another Google+ user, or take a new photo with your web camera (**Figure 3.18**). All of these options are on the left side of the screen.

Left sidebar

In the left sidebar on your profile page are a few important items: two message buttons and the Circle information section.

Just below your profile image are two buttons that allow another Google+ user to send you a private message or an email (**Figure 3.19**). You have full control over who, if anyone, is allowed to use these buttons.

Figure 3.18 When changing your Google+ profile image, you have multiple options to choose from when selecting a new image.

Figure 3.19 These communication buttons are optional and configurable. They allow other Google+ users to contact you directly.

Send a message. This button allows a Google+ user to send a private message to the owner of the profile. The message box that appears is actually a Share box, which is what you normally use to publish content to Google+. The difference is that this message is just between the Google+ user and the owner of the profile. However, you, as the owner of the profile, have the ability to add other Google+ users to the conversation at your discretion.

Send an email. This button allows a Google+ user to email you through your Google+ profile. Your email address will remain hidden, however.

Circle information. Just below the two message buttons is a section that displays information about who you have connected with (**Figure 3.20**). The top section showcases those you have in your circles, and the bottom section displays all of the individuals who have circled you.

By default, these sections are set to display to anyone on the Web. To change the visibility settings, click the "Change who is visible here" link just below the section. A window appears (**Figure 3.21**) that allows you to disable the visibility of these sections or selectively control which circles you want to publicly show. For example, my profile shows that I am connected to 91 Google+ users when in fact I have circled well over 2000. Instead of showcasing all of the individuals I have circled, I choose just to share my Photographer Inspiration circle, which contains some of my favorite photographers on Google+.

Figure 3.20 The Circle information section allows you to showcase who you have connected with and who has connected with you. By default, these sections are turned on.

Figure 3.21 To change which circles you want to display on your Google+ profile, click the "1 circle" box.

Figure 3.22 By finding a creative use of these five thumbnail images, you can give your Google+ profile some character.

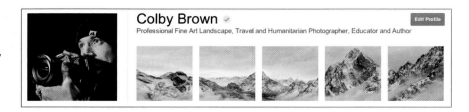

Scrapbook images

Located at the top of your Google+ profile is a set of five thumbnail images (**Figure 3.22**). These images come from an album called "Scrapbook photos," which is connected to your profile. Although you could fill these thumbnails with some of your best work, you can also get creative and create a panorama of a single image that is sliced into five separate thumbnails.

Colby's Quick Tips

A creative panorama thumbnail will have more of an effect than just five of your best images. If you don't have an image that might work, the next time you go out shooting, try to keep it in mind when you are composing your images.

If you search for "google plus thumbnail panorama" on www.Google.com, you'll find a number of tutorials that walk you through the process of cutting up one of your images to fit these thumbnails.

When you have your thumbnails ready, follow these steps.

1. Access your Google+ profile.
2. Click the "Edit profile" button in the top right of your page.
3. Click the "Add some photos here" box.
4. Click the gray Add Photo box.
5. Select the first image of your panorama.
6. Click the "Add photos to scrapbook" button in the bottom-right corner.
7. Repeat steps 4–6 for each section of the panorama.
8. When you're finished, click OK.

Right sidebar

The right sidebar of your Google+ profile contains three sections that allow you to provide links to other websites (**Figure 3.23**): Other profiles, Contributor to, and Recommended links. To edit these sections, click the "Edit profile" button in the top right of your Google+ profile.

Other profiles. In the "Other profiles" section you can add hyperlinks to your Google+ profile to highlight other locations on the Internet where

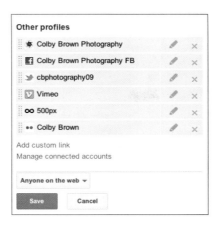

Figure 3.24 **Figure 3.24** This is a list of the profiles that I have linked to on my Google+ profile.

Figure 3.23 The right sidebar allows you to share links to other websites with any Google+ users who have checked out your profile. Photographers often have their work on multiple websites, so don't be shy and list them here.

Figure 3.25 Here is a list of the various service providers that you can directly connect your Google+ account with.

you showcase your photography work. This could be your website or blog, 500px, Flickr, or even your Facebook account.

After you click on the "Other profiles" section, a window appears (**Figure 3.24**). Here you can add a custom link (by clicking "Add custom link") to any website you desire. Google+ allows you to connect with a handful of other service providers with ease.

Colby's Quick Tips

Include links to as many websites that host your photography work as possible. Google+ users are constantly finding me on 500px, Flickr, and Facebook through my Google+ profile.

To connect with these providers, click "Manage connected accounts." You'll then be able to easily connect with any of the providers listed (**Figure 3.25**). The benefits of connecting your Google+ account to these sites are that when you search, you will see relevant content that your friends have shared on the Web and you make it easier for people to find other content you have published outside of Google+.

Contributor to. The "Contributor to" section is meant to showcase other websites that you regularly contribute to. These sites could include other photography blogs that you frequently publish work on, a magazine that you write for on occasion, or even a photography message board that you frequent.

Figure 3.26 The "Contributor to" section allows you to share links to websites that you frequently submit content to.

Figure 3.27 The "Recommended links" section allows you to showcase links to any other websites that you recommend your viewers check out.

You can only add custom links in this section. Click the "Contributor to" link to get started (**Figure 3.26**).

Recommended links. The "Recommended links" section allows you to showcase links to other websites that you recommend other people check out. These sites could include photography related websites you enjoy, other photographer portfolios, or anything else you might be interested in.

You can only add custom links in this section. Click the "Recommended links" link to get started (**Figure 3.27**).

Profile tabs

In the middle of your Google+ profile page are a series of tabs that represent various viewable sections (**Figure 3.28**). Each of these sections allows you to showcase a different aspect of who you are as a photographer. The sections include Posts, About, Photos, Videos, and +1's.

Posts. The Posts section represents all of the content you have published (**Figure 3.29**). Even if some of your posts were private and just between a few individuals, they will appear here. However, anyone viewing your profile will only see the content that you have allowed them to, depending on which circles you originally published your posts to. For more on publishing content, see Chapter 6.

Colby Quick Tips

You have the ability to opt in or out of allowing Google to use your contact information to suggest Google+ users who you have connected with on other sites. This setting is found on the "Manage connected accounts" section of your "Accounts overview" page in your Google+ settings.

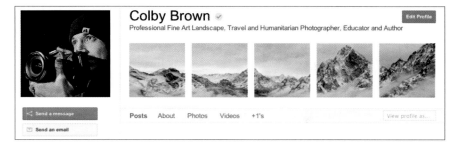

Figure 3.28 Five Google+ profile tabs are found in the middle of your profile page. Simply click the tab you want to view to see that section. The highlighted tab turns red when selected.

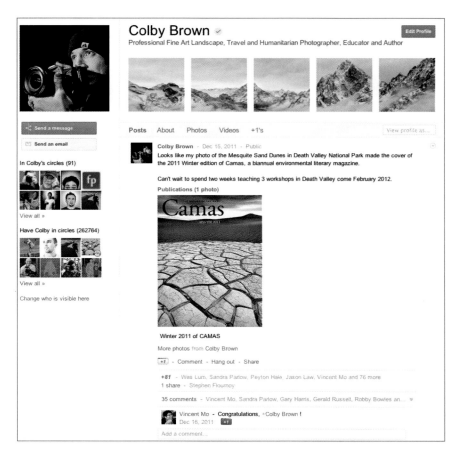

Figure 3.29 The Posts tab displays all of the content you have shared on Google+. Your most recent post is always listed first.

About. The About section acts as your Google+ bio (**Figure 3.30**). Here you can introduce yourself; list where you have worked, where you went to school, and where you have lived; indicate if you are married; provide any contact information; and add a whole lot more.

Figure 3.30 Your About section is one of the more important sections of your profile. You should include all necessary information. Remember that your profile is searchable, so keywords count.

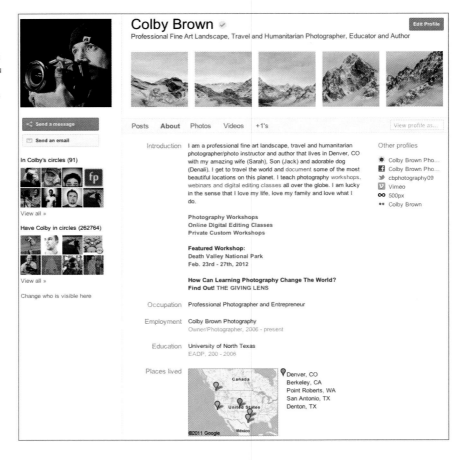

Figure 3.31 To change the visibility of an About section, just click the section while in editing mode. See the "Profile Privacy Control" section earlier in this chapter for more information.

When you are in editing mode on your profile, you will have full control over what information is visible to whom (**Figure 3.31**). Do you want to publicly share your occupation while hiding your relationship stats or home phone number? No problem. Do you want to only share your email address with your family members? No problem.

Photos. In the Photos section (**Figure 3.32**), you'll find three areas of thumbnails: Your shared albums, Photos of you with others, and Photos of you:

- **Your shared albums.** This area contains images and albums that you have uploaded and shared on Google+.

- **Photos of you with others.** This area displays profile thumbnails of other Google+ users that you have been tagged in a photo with.

- **Photos of you.** This section displays image thumbnails of any image on Google+ that you have been tagged in.

Colby's Quick Tips

You can add hyperlinks to the Introduction section on your About tab, allowing you to link to your photography website to showcase any workshops you have available, your photography portfolio, or any other piece of information that you want to make visible on your bio.

Figure 3.32 The Photos section displays beautiful thumbnails of various kinds of images that you are connected with.

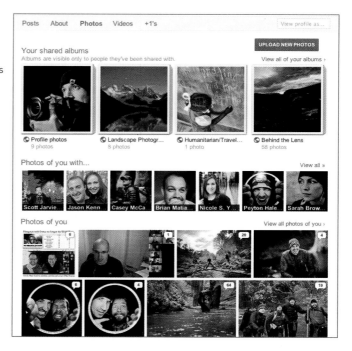

When you are in editing mode on your profile, your Photos tab will display a handful of settings (**Figure 3.33**) that allow you to control how your Photos section works, including the option to turn on or off the ability for viewers to download your images. Be sure to check out these settings before moving on. For more on uploading and publishing photos, see Chapter 6.

Videos. The Videos tab allows you to showcase any videos that you have uploaded directly to Google+ (**Figure 3.34**). The current limitations for uploading a video to Google+ are that it cannot be longer than 15 minutes and the resolution cannot exceed 1080p, which is currently the standard for high-definition movies.

+1's. As discussed in Chapter 1, one of the biggest benefits of being highly active on Google+ is its ability to help influence search engine results. This is done mostly through the Google +1 button, which you can now find in Google+ as well as all over the Internet. The +1's tab contains a listing of all of the Web content outside of Google+ that you have assigned a +1 to (**Figure 3.35**). By default, this tab is hidden, but it can easily be turned on via the profile editing mode if you want to let others see the content you recommend.

Colby's Quick Tips

In editing mode you can control whether or not the Videos tab is visible. By deselecting the visibility box, you can hide it from those viewing your profile.

Figure 3.33 When you are in editing mode on your Google+ profile, clicking your Photos tab will bring up a series of settings relevant to your photo section. Most important is the setting to turn off the option of allowing viewers to download your photos.

Figure 3.34 The Videos tab allows you to show off any of your behind-the-scenes or photo education tutorials that you have uploaded to the network. However, with such tight integration with YouTube, most likely this section will soon allow you to mimic your YouTube channel instead.

Figure 3.35 The +1's tab acts as a catchall for all the content you interact with on the Internet. Note that it does not currently list any content that you clicked +1 for within Google+.

Varina and Jay Patel:
A Photographer's Perspective

Varina and Jay Patel are professional nature and wilderness photographers based in the United States. They teach workshops and webinars, write eBooks, and maintain a blog with tips and tutorials for beginning and advanced photographers. Their award-winning work has been published all over the world by National Geographic, Popular Photography *magazine,* National Parks *magazine, and many more.*

Websites:
Varina: *www.photographybyvarina.com*
Jay: *www.jaypatelphotography.com*

Google+:
Varina: *https://plus.google.com/ 115105647022907007398*
Jay: *https://plus.google.com/ 101145980349117737014*

Q Google+ is a relative newcomer to the social networking world. How is Google+ different than the other networks for photographers?

For business owners like us, social networking is as much about marketing as it is about socializing. Most of us hate to admit that, but the truth is we're running a business here. Google+ lets us get the word out about our products with features that make it far more effective than other social networking sites.

First, we can update, personalize, adjust, and upload images to our accounts easily. Facebook's

settings options are confusing and difficult to find within its scattered interface. The Google+ interface is straightforward and intuitive—and it looks great, too. Our images show up nice and large in the stream, so users will notice them right away. The image browser shows uncropped images—not the standard square crop other sites use—which preserves the integrity of the original image. Combine this with the infinite scrolling feature, and you have an excellent way to browse for photos that catch your eye.

Second, the entire interface is built around encouraging social interaction, not in miniature sound bites like Twitter, but in the form of full-length discussions with diverse groups of people. We can even use the Hangouts feature (which keeps getting better and better) to talk face to face with other users in real time! Google's fantastic search functionality helps us find interesting posts and discussions to join, as well as others who share our passion for photography. At the same time, those search capabilities mean others can find *our* work, too. Google+ makes it easy to share photos, posts, and even circles. And to add icing to the cake, the subscriber model allows users to follow others even if those people don't want to reciprocate.

Third, Google+ lets us take our marketing beyond the norm, getting to know our followers, offering tips and advice, asking and answering questions, and having in-depth conversations with people who become our friends. We've been able to turn

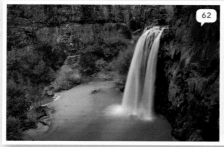

Photo by Jay Patel

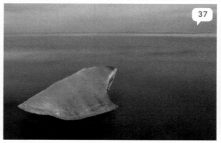

Photo by Varina Patel

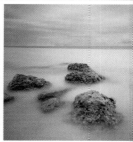

Photo by Jay Patel

marketing into meaningful personal interactions and lasting relationships.

Q Google has spent a lot of time and energy on designing Google+'s user interface. What is your favorite aspect of the interface?

Effective marketing hinges on being able to target your audience. We both agree that circles are our favorite Google+ feature. They let me quickly and easily sort people into logical groups—those who are interested in learning the basics of photography; those who want to learn more complex techniques; those who plan to attend an upcoming workshop—the options are endless. Our circles are constantly evolving to meet our needs. We don't need to spam all our followers with posts and discussions that are meant for a small group of people, and we can keep private posts meant for close friends and family out of the public stream.

We also love the features that allow us to edit posts, include hashtags as searchable links, share instantly, and hang out with other users.

Q Is it important for an individual or company to fully fill out its profile on Google+? Why?

Filling out our Google+ profiles was a priority for us, and we make an effort to update them now and then as well. If users see a post or an image and want more information, the first place they'll visit is likely to be your Google+ profile. This is an opportunity to provide more information about who you are, what you do, and what services you offer. It doesn't take long to fill it out, but a little bit of careful thought about the persona you want to present can go a long way. For an artist or a photographer, a well-organized profile conveys a sense of professionalism and pride in your work. It can also drive business by making it easy for potential clients and customers to find you online.

Q What piece of advice do you have for those filling out their profiles when they start using Google+?

Think of your profile as you would a résumé. Your Google+ profile should showcase your talents and your work, and it should contain organized contact information in an easy-to-read format. We recommend enabling the Send a Message option so that potential customers can contact you easily. Include links to your website and blog, and be sure to include links to any external sites where your products are on display or available for sale. Take a moment to write a few lines that represent who you are—be honest and real, and keep it light. Nobody enjoys reading stiff biographical text. Include your accomplishments, publications, and awards if you'd like, and be sure to include a profile photo. To get ideas for your own profile, take a look at the profile pages of some of the Google+ users you admire. Some are very creative and interesting.

Photo by Varina Patel

Photo by Varina Patel

Photo by Jay Patel

Core Features of Google+

Now that you've signed up for Google+ and have completed your profile, let's take a look at some of the core features of the network. Many of these features I discuss in more depth in the coming chapters, but this overview should provide you with some context for navigating Google+ and making the most out of your time using the service.

Streams

Your Google+ streams are the lifeblood of your Google+ experience. They are not only where you will find all of the content published to Google+, but also where all the interaction and engagement happens (**Figure 3.36**). Google provides you with a variety of filters that allow you to separate the content you view by groupings of individuals (circles) and give you control over noise as well. For more detail on streams, see Chapter 5.

Figure 3.36 Your Google+ streams display all of the content published to Google+.

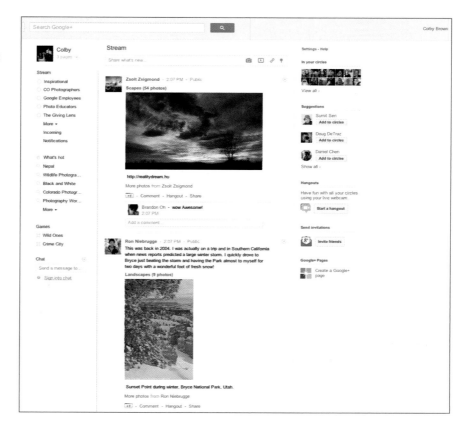

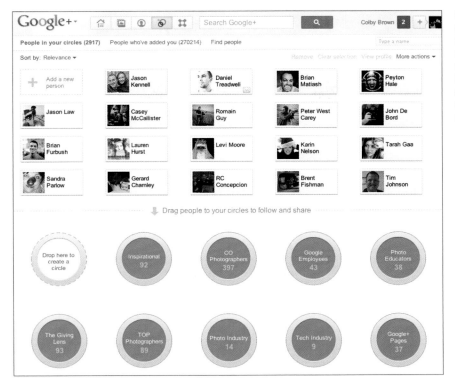

Figure 3.37 By grouping people into circles, you maintain full control over how you interact and what content you share with other Google+ users.

Circles

Circles are Google+'s answer to the complex social relationships everyone deals with on a daily basis (**Figure 3.37**). With circles, you have full control over who you share your content with, as well as what content *you* view in Google+. In Chapter 4 I walk you through how to manage your circles.

Photos

As a photographer, one of the most important features of an online network is how it displays your images. With Google+, there is nothing to worry about. From the endless streams of beautiful thumbnails to the striking lightboxes that display your individual photos, Google+ makes your photographs look amazing (**Figure 3.38**). See Chapter 6 for more about uploading and sharing photos on Google+.

Figure 3.38 In the Photos section of Google+, you'll find an endless stream of thumbnail images from all of the people you have connected with on Google+.

Figure 3.39 The Google+ Hangouts feature allows you to make personal connections with individuals from all over the globe.

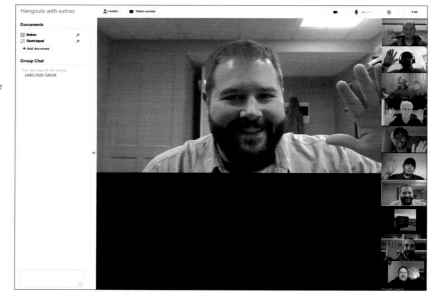

Hangouts

When it comes to interacting and engaging in an online network, the biggest problem to overcome is the lack of personal engagement. With Google+ Hangouts, this is no longer a problem. With hangouts, you have the ability to jump into a group video conference with up to nine other people from all over the world (**Figure 3.39**). You can share screens, watch YouTube videos, and even edit Google+ documents in real time. I explain Google+ Hangouts in depth in Chapter 8.

Google+ Navigation Bar

The Google and Google+ navigation bars sit at the top of every page on Google+ (**Figure 3.40**). The thin black bar at the very top of the screen acts as a road map for you to navigate to any of the other Google products or services that they offer. The more popular options are listed right on the black bar, including Calendar, Search, Images, Maps, YouTube, News, Gmail, and Documents. If you can't find what you are looking for, click on the More tab just to the right of Documents to display everything else that Google has to offer.

In **Figure 3.41**, you will find the Google+ Navigation bar that acts as a guide for getting around the network.

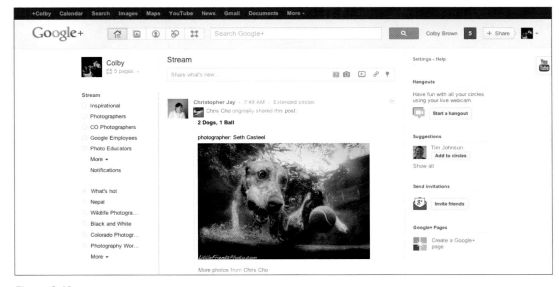

Figure 3.40
Present at the top of every page on Google+ are both the black Google and gray Google+ navigation bars. Using each of these bars, you should have no problems navigating through available features.

Figure 3.41 The Google+ navigation bar allows you to easily move throughout Google+ as well as to all other Google products and services.

Google+ icons

To the right of the Google+ logo are the icons for the various sections of Google+:

- **Stream.** This section acts as the lifeblood of Google+. It is where you view and interact with all the content that is published on the network.

- **Photos.** This section displays an endless stream of thumbnails that represent images that have been uploaded to Google+. You have multiple filtering options on the left side and even the ability to upload new photos (see Chapter 6).

- **Profile.** This section represents your personal page on Google+. It gives you the opportunity to tell other Google+ users about you, display your photography work, and share links with all other relevant websites that relate to you as a photographer.

- **Circles.** This section gives you full control over both the complex and simple relationships you form on Google+. You can group individuals into circles, which help you dictate who you share content with and what content you want to view from others.

- **Games.** Although I don't talk about the Games section in this book, it is a very popular Google+ feature. You can interact with other Google+ users, play a variety of games, compare high scores, and even challenge each other in multiplayer games. Unlike other social networks, you have the ability to turn off all notifications from the Games section.

Search box

Located in the middle of the Google+ navigation bar at the top of your screen is the Google+ search box (**Figure 3.42**). Here you can search for Google+ users, any content published on Google+, and even popular Internet topics. Google+ gives you a pretty advanced set of filtering tools to ensure that you find what you are looking for. See Chapter 5 for more details about the Google+ search box.

Search Google+

Figure 3.42 The Google+ search box allows you to find nearly anything you could imagine on Google+.

Notification box, Share box, and Google+ account information

Located on the right of the Google+ navigation bar are the Notification box, Share box, and account information menu (**Figure 3.43**).

Notification box. The Google+ Notification box acts as a constant reminder of all of your interactions on the network. By default, the box is clear and displays a 0 in the middle of it. However, when someone has interacted with you, the box turns red and the number displayed indicates the number of notifications you currently have waiting for you. If you click the box, a window appears showing your notifications (**Figure 3.44**). I talk more about the Notification box in Chapter 5.

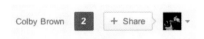

Figure 3.43 The right side of the Google+ navigation bar is certainly not to be missed. However, with the Notification box in the corner, you will have a hard time ignoring it regardless.

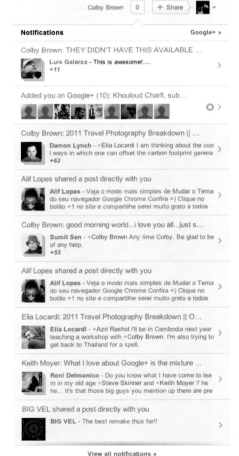

Figure 3.44 Inside the Notification window you'll find short descriptions of the various notifications you have received. Notifications that you have already viewed will have a gray background; new notifications will be white. Click a notification to view the actual interaction.

Figure 3.45 The Google+ Share box in the navigation bar gives you complete access to publishing content from any page within Google+.

Figure 3.46 The account information menu provides quick access to many settings and features on Google+.

Share box. The Share box is where you can create and publish content to Google+. Although a Share box is embedded on your main Google+ home page, the box in the navigation bar allows you to create and publish content from any section in Google+. By clicking the Share icon, a window appears allowing you to share content (**Figure 3.45**). See Chapter 6 for more on sharing content and photographs.

Account information. In the very corner of the navigation bar you'll find a small thumbnail image of your profile photo. By clicking the thumbnail, a menu appears that provides direct links to your Google+ profile, home page, account settings, and privacy controls. The menu also gives you the option of signing out of Google+ (**Figure 3.46**).

Google+ Product Integration

As you are probably already aware, Google is much more than just Google+. With hundreds of millions of customers using a wide variety of Google's products and services, it is only a matter of time before they are all pulled in under the umbrella of Google+. As mentioned previously, signing up for Google+ means that you must create a Google account to access all of the Google+ products mentioned earlier in this chapter.

Google is investing a lot of money into Google+, and every month more features and Google products are integrated into the network. By being the king of search on the Internet, Google+ is quickly becoming the hub for all things digital.

Colby's Quick Tips

As Google continues to integrate more and more of its products into Google+, you'll find more photographers, clients, and potential customers joining the network. Google+ is already the fastest growing online network in history, so get out there and start building your following. More users are joining every day.

Changing Your Google+ Settings

Google+ is all about giving control to the end user. This mind-set is not just about controlling who you connect with and how, but it also dictates your overall experience on the network. Unlike other social networks, the bulk of your Google+ settings are not buried under several different menu layers.

Privacy Settings

One of the hottest topics when it comes to connecting with people on the Internet is privacy control. Every time Facebook changes a feature, people are up in arms because of how it directly affects their ability to control who can see their content and information.

To access your privacy settings, follow these steps.

1. Click the mini thumbnail image on the far right of your Google+ navigation bar.

2. Choose Privacy from the menu.

On the "Profile and privacy" page that appears (**Figure 3.47**), you'll notice that it is broken into various sections: Google Profiles, Sharing, Google+, and Google privacy.

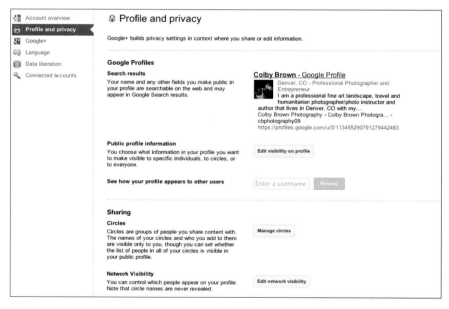

Figure 3.47 The Google+ "Profile and privacy" page gives you full control to limit the visibility or interactions that others can have with you on the network.

Every feature contains a thorough description that explains the setting you are attempting to adjust. Many of the buttons on the page are links to other sections of Google+ where the actual controls for the respective sections exist.

One other very important section for privacy settings is found in the Google+ tab in the left sidebar of the current page. When you click the Google+ link, you will be directed to a new settings page. Here you will find the "Who can interact with you and your posts" setting. This allows you to control who can send you notifications, who can comment on your public posts, and who can start a mobile Messenger conversation with you. By default, these are set to Anyone on Google+.

Notification Settings

As you continue to connect and engage with more and more people on Google+, you will naturally start to receive more and more notifications. By default, Google+ will send you email notifications as well as light up the Notification box from within the network by turning the Notification box bright red. After you've connected with a few hundred people, your email inbox will quickly and constantly fill up. You also have the option of connecting your cell phone number to Google+ so you can receive SMS notifications too. Although this might not sound like a great idea, the notification settings allow you full control over which notifications, if any, you want to receive via email or phone.

To access your notification settings, follow these steps.

1. Click the mini thumbnail image on the far right of your Google+ navigation bar.

2. Choose Account Settings from the menu.

3. In the left sidebar, click Google+.

About a quarter of the way down the page are the notification settings. The first section deals with notification delivery. Here you can add your cell phone number to receive SMS updates.

To shut off email notifications, make your way to the "Receive notifications" section (**Figure 3.48**). Here you have full control over all of the various types of notifications and how you want to receive them. Deselecting all of the boxes under Email means that you will not receive any email notifications from Google+.

Receive notifications		
Notify me by email or SMS when someone...		
Posts	Email	Phone
Mentions me in a post	☐	☑
Shares a post with me directly	☐	☑
Comments on a post I created	☐	☑
Comments on a post after I comment on it	☐	☐
Circles	Email	Phone
Adds me to a circle	☐	☐
Photos	Email	Phone
Tags me in a photo	☐	☑
Tags one of my photos	☑	☐
Comments on a photo after I comment on it	☐	☐
Comments on a photo I am tagged in	☐	☐
Comments on a photo I tagged	☐	☐
Messenger	Email	Phone
Starts a conversation with me	☐	☑
Communications about Pages	Email	Phone
Receive updates and tips that help me get the most out of my Pages	☑	☐
Learn about the latest changes, enhancements and new features	☑	☐
Learn about related Google products, services, events and special promotions	☑	☐
Participate in surveys and pilots to help improve Pages	☑	☐
Google +1		
+1 on non-Google sites	On Edit	

Figure 3.48 Be sure to thoroughly look through the various notification settings so that you can adjust the right notifications and make sure you receive the ones you feel are important.

Photo Settings

As a photographer, controlling who can view and download your images is an important feature of any network you are thinking about joining. Although most of the photo settings are geared more toward the average user, you still have the ability to not allow someone to download your images on Google+. Note that although turning off this setting doesn't allow a Google+ user to use the Download Image option on your image (which downloads the photo at the resolution you uploaded it at), others can still take a screen shot or use a mouse to drag and drop your image from their web browser to their desktop.

Colby's Quick Tips

I allow other Google+ users to download my images because I feel that it helps to promote marketing for my business. I apply a very small text watermark to my images that lists my website address. Whether a user gives me credit for my image or not, the exposure has helped my business grow substantially, not just on Google+.

Photos

☑ Show photo geo location information in newly uploaded albums and photos.

☑ Allow viewers to download my photos

☑ Find my face in photos and prompt people I know to tag me. Learn more

People whose tags of you are automatically approved to link to your Profile:

○ Family × ○ Friends × + Add more people

When a tag is approved, it is linked to your profile, and the photo is added to the "Photos of you" section.

You can change the visibility of your photos and videos tabs on your profile.

To access the photo settings, follow these steps.

1. Click the mini thumbnail image on the far right of your Google+ navigation bar.

2. Choose Account Settings from the menu.

3. In the left sidebar, click Google+.

At the bottom of the page that appears, you'll find a section called Photos (**Figure 3.49**). Here you can deselect the option to allow users to download your image, adjust photo-tagging options, and change the visibility of the geo location of your images.

Page Settings

If you decided to create a Google+ business page, you too have a handful of options at your disposal.

To access your Google+ page settings, follow these steps.

1. Change to your Google+ page account by clicking the down arrow just to the right of your mini thumbnail image on the left sidebar of your home page and selecting the page in question.

2. On your Google+ page home screen, click the Settings link at the top of the sidebar on the right.

Notice that there are two options in the left sidebar: General and Managers.

General

In the General section (**Figure 3.50**) you have control over who interacts with your page posts. You can also add an email for email notifications, and you can change your photo settings for the page in question.

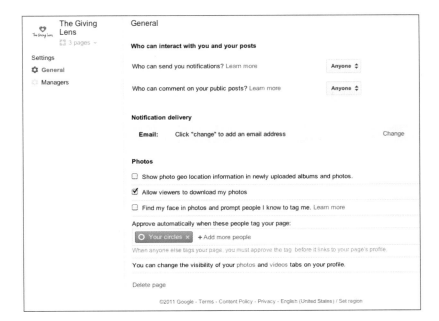

Figure 3.50 The General section offers you control over the basic settings for your page.

Managers

One of the most exciting features of a Google+ page is the ability to have multiple administrators, or managers as Google+ refers to them. You can set up these managers in the Managers section of your page settings (**Figure 3.51**).

You must know the email address of those you want to assign, because Google+ does not currently allow you to set up a manager via just a user account.

Figure 3.51 The Managers section of your page settings allows you to add multiple managers to help you run your page. This is a must-have feature for large companies.

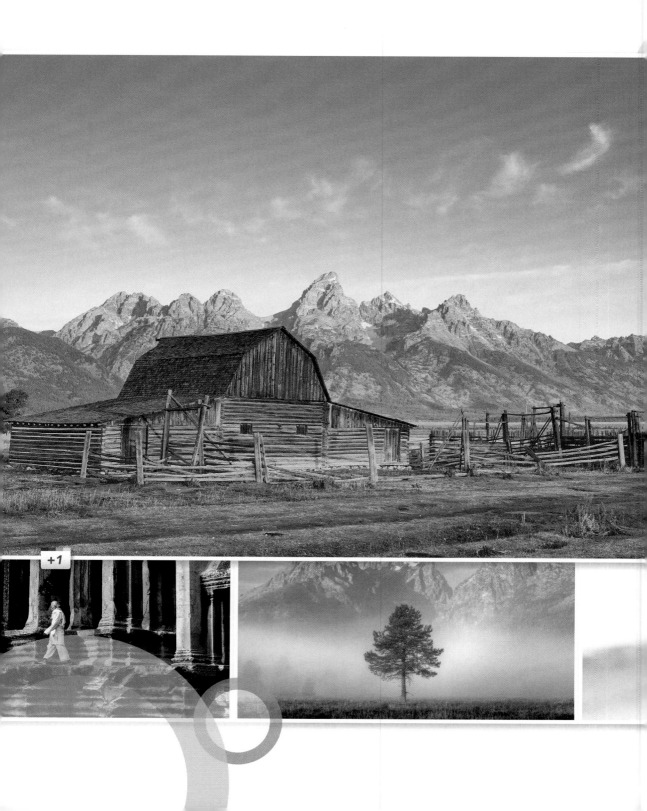

+1

4C

Working with Circles to Stay Organized

Circles are Google's answer to the diverse social layer issue that is found in most online social networks. In the digital age we live in, we are constantly trying to simplify our lives. Although this is possible with menial tasks, such are paying our bills online or researching the next piece of camera gear we want to purchase, the various degrees of human interactions are far more complex.

A computer system cannot predict the organic and dynamic flow of a relationship over time. Life is not stagnant, but instead is dynamic—always changing and always moving forward. To accurately and effectively manage your interpersonal relationships online, you need control. You need choice. This is where the Google+ Circles feature steps in.

In this chapter, I'll explain what circles are, how to use them, and how to organize them so that you can get the most out of your time on Google+.

What Are Circles?

As individuals, we are constantly interacting with a multitude of different types of people throughout life. On a given day you might pick up the phone and call a friend or a professional colleague, or maybe even a family member to share and receive specific information. Although you wouldn't necessarily have the same conversation with all three, there might be some overlap. For example, in **Figure 4.1**, you might have three groups of individuals that you connect with on a regular basis: Friends, Clients, and Photographers. Even though Rose is a friend, she also happens to be a photographer. However, she is not one of your clients. So although you might share with her some personal information because she is a friend or ask her to go on a photography trip with you because she is a photographer, you would not send her the marketing newsletters that you send your past clients.

Interpersonal communication is rich, has depth, and is not always symmetric. Google+ addresses these complexities by allowing you to selectively gather those you want to connect with into various groups, otherwise known as *circles*. Circles are arguably the most important feature of Google+ you need to understand because they control how you communicate and connect with customers, clients, photographers, and everyone else on Google+.

Figure 4.1 An example of the often complex interpersonal relationships we all have in our daily lives.

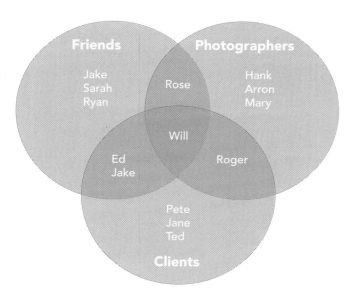

Figure 4.2
A selection of my top Google+ circles containing people I connect with more frequently than others.

How Do Circles Work?

Circles (**Figure 4.2**) act as filters for all content being shared on Google+. They allow you to control not only who you share your content with, but whose content you want to view as well.

They function in a manner very similar to how lens filters work. For example, as photographers, we have the ability to filter out certain spectrums of light or even color with specific filters that we attach to our lenses. These tools give us more control over what we see and what we are capable of capturing with our cameras. Google+ circles work in the same way. You have the ability to create a circle that contains just your family members, your clients, or other local photographers. By doing so, you can then share content and information with just those individuals. On the flip side, you can utilize those same circles to filter out content, information, and media coming to you through Google+. If you want to only see what your clients, friends, or other local photographers are publishing, it is as simple as a mouse click (see Chapter 5).

Circle Organization

All of your circle management needs are on the Circles page. To access that page, locate the gray Google+ navigation bar located near the top of your screen (**Figure 4.3**) and click the Circles icon, which is the second from the right.

The Circles page appears. **Figure 4.4** shows the general layout of the Circles page. Let's explore this page and some of its key elements.

Colby's Quick Tips

Circles are private in that if you add me to one or more of your circles, I am notified that you have added me to your circles, but I do not know which circles I have been placed in.

Near the top of the screen you'll find three main tabs—People in your circles, People who've added you, and Find people—that allow you to filter through the individuals that you are connected with. In the middle of your screen are the Google+ profile thumbnails, and at the bottom of your screen are your circles.

Figure 4.3 The Google+ navigation bar makes it easy to navigate through not only the various Google+ features, but all Google products as well.

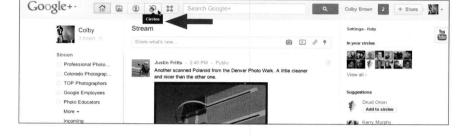

Figure 4.4 The Google+ Circles page allows you to easily manage all of your connections with Google+. Here you can sort individuals into circles, view who has circled you, and import people from your computer address book.

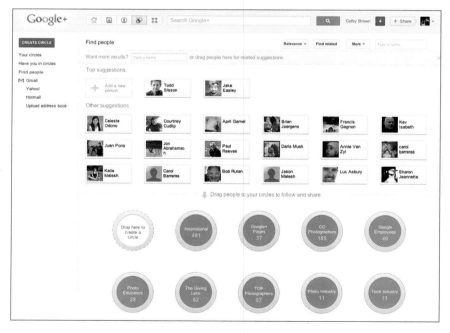

Advice on Setting Up Your Google+ Circles

Before you begin adding Google+ profiles into your circles, it is important to understand why you signed up for the service. Here are some helpful questions to consider before you get started:

- What are your goals for signing up for Google+?

 Many photographers wander aimlessly in the social networking world. By defining your goals, you can devise a better plan for how you want to engage other individuals on Google+.

- Are you using Google+ to expand your photography business?

 If you are using Google+ to sell photography prints, you need to look for customers. But first you need to determine who your clients are. Unless you are a photo educator, typically, photographers are not your clients.

- Are you using the service to learn from professionals?

 If you are using Google+ to improve your photography skills, you should add professional photographers you admire to your circles. There are thousands of professional photographers that are eager to share their knowledge and experiences with you.

- Are you interested in finding inspiration from other photographers?

 If you are using Google+ to find inspiration from other photographers, you certainly will not find a shortage of amazing images to view. Google+ is a global network with millions of people from all over the world. Check out the "Making Connections" sidebar later in this chapter to find lists of photographers on Google+.

The answers to these questions should help dictate your approach to connecting with people through Google+. Remember to be selective and only circle individuals that you want to connect with. Photographers commonly make the mistake of always wanting or needing the approval of other photographers. Google+ is not a popularity contest, and it is much more important how you interact with those you circle than the sheer number of people in your circle or that circle you.

A great starting point is the Google+ search box located at the top of every page. Here you can search all of Google for people by location, keywords, and names of individuals that you want to connect with.

Creating a Circle

To create a circle, you have three main options:

- You can drag and drop multiple Google+ profile thumbnails into the first circle (**Figure 4.5**) and click Create Circle. Then click the blue Create Circle link inside the first circle to easily name and finalize the creation of the circle (**Figure 4.6**).

- You can move your mouse over the first circle (**Figure 4.7**), and the text inside the circle will change to a "Create circle" link (**Figure 4.8**). Click that link to open the box that will allow you to easily name your new circle as well as populate it with the desired profiles (**Figure 4.9**).

Figure 4.5 Drag Google+ profiles to add people to a new circle.

Figure 4.6 Name the newly created circle using a descriptive name that represents its members.

Figure 4.7 The standard view of your Google+ Circle section.

Figure 4.8 By hovering your mouse inside the white circle, the text changes to "Create circle."

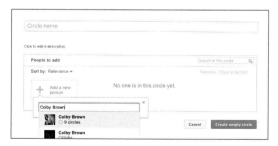

Figure 4.9 Now you can name and populate your new circle.

- When browsing through Google+, hover your mouse over a Google+ profile name. A box appears that allows you to click the Add to Circles button, which then displays a number of options. At the bottom of your Circle options is the "Create new circle" link (**Figure 4.10**). Click that link and add the selected profile to a brand-new circle.

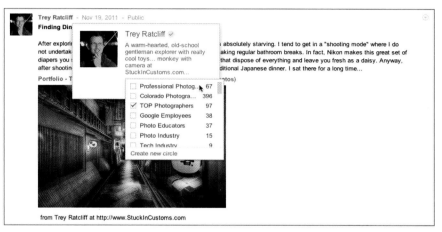

from Trey Ratcliff at http://www.StuckInCustoms.com

Figure 4.10 After you have clicked the Add to Circles button, a box appears allowing you to add the profile to a new circle or a circle you have already created.

Making Connections

Google+ is unique in that it allows you to have total control over your user experience. Making connections with other individuals and businesses will help dictate whom you interact with and what information you see coming through your streams. As a photographer, you have a multitude of third-party websites that can help you find and connect with the thriving photo community on Google+.

Here are a few examples:

- **Group/As (www.group.as).** A website that allows users to create custom lists of Google+ users.

- **Recommended Users (www.recommendedusers.com).** A website that offers its own curated lists, which include groups of photographers, such as Most Followed, Inspirational, Landscape & Wildlife, Portrait / Wedding, and more.

- **Google+ Counter (http://gpc.fm).** Similar to Group/As, this website offers users the ability to create custom user lists of various kinds.

Scott Jarvie:
A Photographer's Perspective

Scott Jarvie is a wedding and portrait photographer and photo educator based out of Salt Lake City, Utah. He puts a piece of himself into everything he does, which is a testament to his success as a professional photographer and the reason his images are full of personality and emotion. When he is not giving presentations or capturing a bride's most special moment, he is partaking in his love of travel photography through various trips around the world. It doesn't hurt that he is fluent in five different languages.

Website: *www.jarviedigital.com*

Google+: *https://plus.google.com/100962871525684315897*

Q Why are circles an important feature of Google+?

Circles create the foundation of our communication on Google+. Circles dictate who you're speaking to (when you have something to share) and who you're listening to (when you feel like seeing what's going on). For me, circles also help me remember how I know this person, like quick labels.

Q Does organizing your circles make a difference in your Google+ experience? Why?

Yes. I have a lot of circles, and keeping them organized helps me apply the circles quicker so that it is less of a chore. I organize my circles by putting the most important or most used circles higher in the list so I don't have to scroll down to find them. Using a number in addition to naming my circles helps me by associating the numbers and finding the circles faster when publishing content to those circles.

Q What are the top five circles you think every photographer should create on Google+?

The five types of circles I think every photographer should create include:

- **Photographers by location.** Especially those in your own region.

- **Photographers by style.** Especially those using the same style of photography as you do. For me, that's weddings and travel photography.

- **Photography business pages.** Because the vendors and product makers are great to

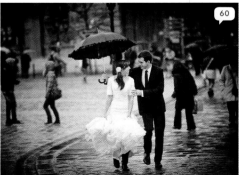

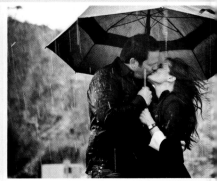

follow. My tip is to name the circle using (p) in front so you know it's a circle of pages.

- **Nonphotographer circles.** This circle is probably the most important because if the majority of what you share is photography, then most times the only things you'll direct specifically to a circle are nonphotography posts.

- **Most interesting.** Whether it be lists of the most interactive photographers, photographers you are friends with, or the photographers that inspire you the most, you'll need a couple of circles that will be your go-to circles when you want to quickly and easily find helpful content.

Q What tips do you have for maintaining your circles in the long run?

Besides all the tips I've already listed, I think people should

- Remember that creating circles and then adding lots of people to them later on when your circles have already been established is a lot of work.

- Make a list of all the circles (based on the five types of circles listed previously) you think you might ever use or want to use. Circle people from the get go. Users will naturally find that they gravitate to using certain circles; later on they can decide to remove the ones they didn't use often.

- Do everything I stated in question 2.

- Most of all, don't stress about circles, and don't let them become a deterrent to using Google+.

The sky is the limit when it comes to the kinds of circles you can create. **Table 4.1** lists a number of potential circles that you can create and utilize.

Table 4.1 Different Types of Circles

Circle Type	Definition
Family	This circle consists of family members.
Friends	This circle consists of friends.
Coworkers	This circle consists of coworkers.
Local Photographers	This circle consists of photographers who are based out of your current location.
Clients	This circle consists of clients you have worked with in the past.
Photo Industry	This circle consists of key players in the photo industry who work for various companies.
Photo Educators	This circle consists of photographers who teach photography classes, workshops, seminars, and webinars.
Google Employees	This circle consists of Google employees who share information and new Google+ features.
Google+ Pages	This circle consists of various business pages found on Google+

Renaming Circles

As you continue to become more engaged within Google+ and you begin to connect with a variety of different people, you might need to refine the names of your circles to stay accurate. For example, you might have created a circle called Colorado Landscape Photographers only to realize that you want to add Colorado Wildlife Photographers to it as well. To rename a circle, perform the following steps.

1. Click the title of the circle you want to rename (**Figure 4.11**).

Figure 4.11 Select the circle you want to rename.

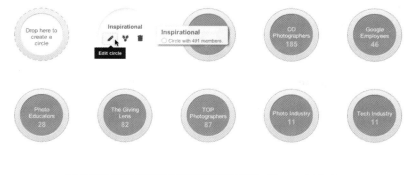

Figure 4.12 Click Edit to make any changes needed.

Figure 4.13 Rename your circle and enter any descriptive text desired.

2. Click the Edit icon, represented by a graphic that looks like a pencil. (**Figure 4.12**).

3. Fill in the necessary information in the correct boxes (**Figure 4.13**).

4. Click Save.

Reordering Circles

Changing the order of your circles not only allows you to customize your Google+ Circles page, but it makes filtering the content you view on Google+ that much easier. Google+ will display the first five circles you have listed in your Circles page in the sidebar on the Google+ home page. Selecting one of these circles allows you to view published content from only individuals in the selected circle. The circles you interact with the most should be first.

To change the order of your circles, follow these steps.

1. Click and hold on a circle that you want to reorder.

2. Drag the selected circle to the location at which you want to place the circle.

3. A gray line appears (**Figure 4.14**) to indicate the placement of the circle being moved.

Colby's Quick Tips

When you're looking for people to connect with on Google+, the Search bar is a great place to start. For example, you can search for "Colorado Photographers" and find a dynamic list of people to add to your circles.

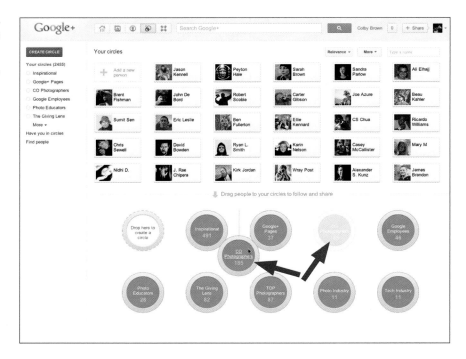

Removing Profiles from Circles

As you continue to engage and interact with more and more photographers and clients on Google+, you might find the need to remove certain individuals from your circles that you no longer want to connect with. You can remove profiles using the Circles page or the Profile page. Let's look at both ways to do this.

To remove profiles using the Circles page, follow these steps.

1. Click the title of the circle you want to remove (**Figure 4.15**). All of the Google+ profiles in that circle will populate the profile thumbnail area above the Circle section.

2. Click the profiles you want to remove. When clicked, the selected profiles will turn blue (**Figure 4.16**).

3. Click the Remove button located just above the profile thumbnails.

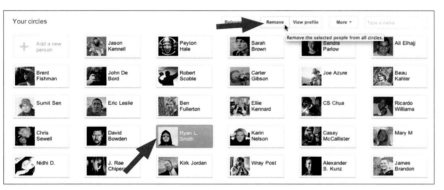

Figure 4.15 Select the circle that you want to modify.

Figure 4.16 Select the Google+ profiles you want to remove, and then click the Remove link.

Figure 4.17 Click the green box at the top right of the Google+ Profile page to see which circles contain this profile.

Professional Photog...	67
Colorado Photogra...	396
TOP Photographers	97
Google Employees	38
Photo Educators	37
Photo Industry	16
Tech Industry	8
Create new circle	

Figure 4.18 Deselect all the circle boxes containing the profile.

To remove profiles using the Profile page, follow these steps.

1. Go to the Profile page of the individual or business you want to remove.

2. Click the green box in the top right of the web page (**Figure 4.17**). This box represents the circles you currently have this profile in.

3. Deselect the check boxes next to the circles that you currently have this profile in (**Figure 4.18**).

Sharing Circles

Circle sharing is one of the best ways to get people to circle you. If you see others asking for "landscape photographers," and you happen to photograph landscapes, comment on their post and try to get them to add you to their circle. When they share that circle to the public or with their circles, you have a good chance of other photographers connecting with you and adding you to their circles.

To share a circle from your Circles page, follow these steps.

1. Click the name of the circle you want to share (**Figure 4.19**).

2. Click the Share link in the circle you originally selected (**Figure 4.20**).

3. Add text in the Comments section to describe the circle you are sharing, and then choose the circle you want to share this group with (**Figure 4.21**). Sharing to Public will always allow you the most visibility.

4. Click the green box titled Share.

Figure 4.19
Select the circle you want to share with others.

Figure 4.20 By clicking the Share icon, a box will open, allowing you to easily share your Google+ circle with others.

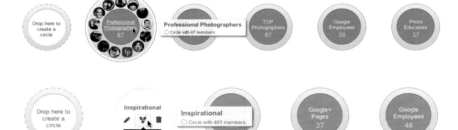

Figure 4.21 Add text to the Comments section of the circle shared to provide details about the circle.

Colby's Quick Tips

Currently, there is a 500 person limit to the circles that you can share. If you share a circle with 1000 people in it, it will only share the names of 500 individuals.

Public vs. Extended Circles

When you get ready to start sharing photographs and content on Google+ (see Chapter 6), you will find two main circles that come standard with every Google+ account: Public and Extended Circles. Understanding the difference between the two is important.

Public Circles

When you share content to the Public circle, it is visible to everyone on Google+ as well as the entire World Wide Web. As a search giant, Google works hard to make sure it indexes all public Google+ posts for search results. By performing a Google search of "Colby Brown Photography" (**Figure 4.22**), you'll notice that not only does my Google+ profile appear as a result, but a popular Google+ post as well.

Figure 4.22
A Google search reveals that Google+ posts are searchable.

Although the benefits of posting to your Public circle are that everyone can see what you publish, it can also be a drawback. Not everyone who adds you to his or her circles might want to see everything you send out via Google+. As a rule of thumb, I never publish content that talks about religion, politics, or polarizing topics to my Public circle unless I truly feel compelled to. As a photographer, my name is my brand, and I don't want to alienate potential clients, customers, or friends because of my beliefs.

Extended Circles

Understanding what happens when you publish content to your Public circle is fairly straightforward, but publishing to your Extended Circles is not as clear-cut. The reason is that the group of people in your Extended Circles is constantly changing. Your Extended Circles are in essence everyone in your circles, plus everyone in their circles. Think of it as your circles' circles. However, Extended Circles only go two connections deep.

For example, if I am in your Colorado Photographer's circle and you publish content to that circle, I will be able to view it. But my friend Scott Jarvie in Utah would not be able to because he is not in that specific circle. However, if you publish your content to your Extended Circles, Scott Jarvie would be able to see the content, because even though he is not in your circles, he is in mine.

Melaine Schweighardt:
What Google+ Means to You

As a freelance photographer and a photo enthusiast, I'm always searching for that amazing shot. I love it all; from majestic landscapes to an emotional portrait and everything in between. My inspiration comes from so many amazing people (family, friends, and other photographers). I just hope I can pay it forward to a fellow photo enthusiast. That would be amazing!

Website: *http://photoswithhardt.blogspot.com*

Google+: *https://plus.google.com/ u/0/100019364506073195455*

Essay

Photography is a passion that ignites a feeling, a conversation, a memory, a moment in time. It captures someone's vision. It is a link to our past and leaves a legacy for our future. I have been interested in photography since I was 4. My mother is also a photographer. She took me to the Appalachian Trail (High Point, New Jersey) during autumn when the leaves were changing. She put a Kodak Instamatic camera in my hand and said to me, "Look out there; when you see something interesting, click this button." We spent the next few hours hiking and taking pictures. She let me get familiar with my camera and my surroundings and guided me toward some great shots. It's the common bond that linked us from that moment on. Her passion became my passion.

That's the thing I love about Google+. I am able to share that passion with amazing photographers. It doesn't discriminate; amateurs and professionals meld together, inspiring one another. It is a community of artists that teaches, shares, and showcases these wonderful creations. Every day I am inspired to grab my camera and try something new. It's a way of sharing what you know, what you do, and who you are. It gives me a place to get lost and enjoy myself while I journey through other people's adventures, and it inspires me to share mine. I am grateful and excited to be part of a circle of amazing people. Now, I just have to get my mom to sign up.

5

Learning How to Interact on Google+

As mentioned previously, Google+ is an online network that thrives on connections and interaction. It is an information and media-streaming powerhouse that allows you to engage with all kinds of individuals who share your interests and passions. However, as you continue to connect with more and more people on Google+, you'll need to control how you view and interact with content.

Google+ offers a handful of unique tools and features that make handling content a simple process. In this chapter, I'll discuss the use of Google+ Circles, filtering your stream, and dealing with spam. I'll also give you pointers on how to use the Google+ search and explain the difference between blocking and ignoring an individual.

Understanding Your Google+ Stream

Stream

The Google+ Stream is the lifeblood of Google+. It is the medium in which the main flow of information, ideas, photos, videos, and Google+ features become visible to the end user. Basically, it centralizes all of the content people have shared with each other into an endless stream. To access your main stream, click the Home icon in the Google+ navigation bar (**Figure 5.1**).

How Does Your Stream Work?

Figure 5.1 The Home icon on the Google+ navigation bar brings you to your home screen, showcasing your main stream of content.

As mentioned in Chapter 4, circles are Google's answer to the various dynamic layers of interpersonal communication that we experience in our real lives. By grouping individuals into circles, you can effectively control the flow of information throughout the entire network.

In essence, Google+ Circles filters all of the information that flows through your stream. When you initially visit your Google+ home page, content from everyone you have circled on Google+ is displayed in your stream (**Figure 5.2**). Although this might not be an issue when you've only added 100 people to your circles, it can be daunting to keep up with everyone and everything that is being shared when you have circled 4000 individuals. This is one of the primary reasons that circle management is so important in Google+. If you have taken the time to break down the various types of connections that you've made into separate circles, you'll gain total control over your stream.

> **Colby's Quick Tips**
>
> Carefully choose the order of your Google+ circles. My top five circles are Inspirational Photographers, Colorado Photographers, Photo Educators, Google Employees, and Google+ Pages. I interact with individuals in these circles more so than anyone else on the network, and having them one click away is a big time-saver.

Located just under your profile thumbnail on the Google+ home screen are the various circle filters for your stream. To view the content from a specific circle, simply click the corresponding circle title of choice. Google+ displays the names of your first five circles in this section (**Figure 5.3**); however, if the circle you are looking for is not in the initial section, you can click the More link to show all of your circles.

The title of the circle filter you are currently using sits at the top of your home screen, just below the Google+ search box (**Figure 5.4**). When the title stream is displayed, you know you are using the default setting, which shows you content from everyone you have circled.

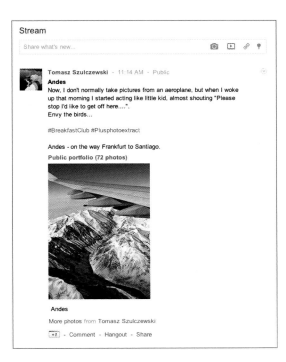

Figure 5.2 The default stream of content shown on your home screen allows you to view content from everyone you have circled on Google+.

Figure 5.3 Your first five circles appear in the left sidebar of your home screen, allowing you easy access to filter your stream to only view content from these circles.

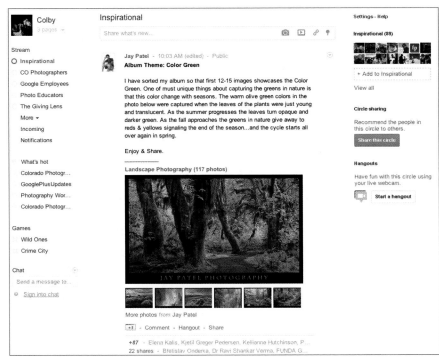

Figure 5.4 By clicking my Inspirational circle filter, my stream will now only show published content for the individuals in that circle. I know which filter is being applied by the title of the stream being displayed.

> **Google Employees**
>
> Share what's new...
>
> **Show most things from this stream in my main stream**

Priority controls for your stream

Although you certainly have the ability to use your circles to completely filter out the content you want to view, you might want more control over your main Google+ stream that displays content from everyone you've circled. With Google+, you have the ability to fine-tune your stream by giving priority to some circles over others, allowing you to see more content from those you are most interested in connecting with.

This is done through a simple slider that is found at the top of every circle filter page (**Figure 5.5**). To get to the correct page, click the title of the circle you want to fine-tune on your home screen in the left sidebar. The slider is located just above the Share box and to the right of the title of the circle at the top of the page. You have four levels of control. Starting with the slider on the far left and moving to the right, these controls include the following:

- Show nothing from this stream in my main stream
- Show fewer things from this stream in my main stream
- Show most things from this stream in my main stream
- Show everything from this stream in my main stream

Colby's Quick Tips

I make sure I see all of the content from a handful of certain photographers on Google+.

Colby's Quick Tips

Relationships on Google+ are not a two-way street like many other social networks; they operate in a single direction (see Chapter 4). When you circle someone, it allows you to view the content that person shares. But for that person to see what you publish, the individual has to circle you back. Until this happens, the Incoming section will contain the content you publish to individuals who have not added you to their circles.

Interacting with Google+ Posts

As you are viewing content that is flowing through your various Google+ streams, you have a variety of ways in which you can interact and engage with other Google+ users.

Leaving a Comment

Located at the bottom of every post on Google+ is a box that displays the words "Add a comment" (**Figure 5.6**). Here you can share a comment about the post as well as tag someone so that person is notified to check out your comment.

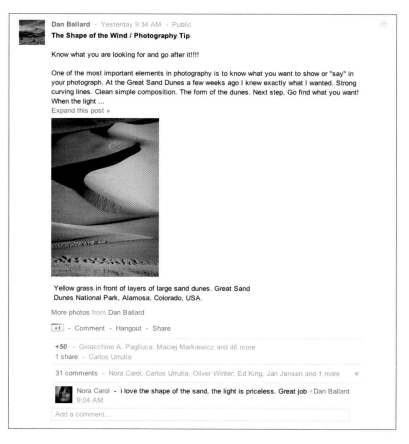

Figure 5.6 Leaving comments on Google+ is a great way to engage with other individuals on the network. By interacting with other people, you have a higher chance of them adding you to their circles.

Although you do not have the ability to use HTML code to leave a dynamic comment, you do have a few options when it comes stylizing your words:

- **Bold.** By adding an asterisk (*) before and after a word (or string of words), you can enable the Bold stylization. For example, *photography* would read **photography**.

- **Underline**. Add an underscore (_) before and after the word(s) that you want to underline. For example, _Google+ for Photographers_ would read Google+ for Photographers.

- **Strike Through.** To add a strikethrough as though you are editing a word or a string of words, add a hyphen (-) before and after the selected word(s). For example, Tomorrow I am leaving at -9am- 8am would read Tomorrow I am leaving at ~~9am~~ 8am.

Tagging an Individual or Google+ Page

To get the attention of another Google+ member, you can tag that individual in a post or a comment. By doing so, a notification will be sent to that member so that the person has a higher chance of seeing the comment or post in question.

To tag an individual, simply add the + or @ character before you type the person's name. When you start to type a name to tag, Google+ provides suggestions based on the letters typed and the names in your circles (**Figure 5.7**). Google's recommendations even include a profile thumbnail image for you to ensure that you are tagging the right individual. So, for example, if you type +Colby Brown or @Colby Brown, you will tag me.

Sharing a Post

One of the best ways to engage with others is to share a post with your own circles (**Figure 5.8**). Google+ is based on interaction and engagement, so there is no better way to show that you enjoyed a post on Google+ than to share it with your circles and spread the word.

To share a post, follow these steps.

1. Click the Share link located at the bottom of the post in question.

2. Type anything you would like to add to the share of the post in the blank box located at the top of the pop-up window.

3. Don't forget to correctly choose which circles you want to share the post with in the bottom box. You can also share the post with individual people instead of an entire circle. To do so, just type in their names in the same location.

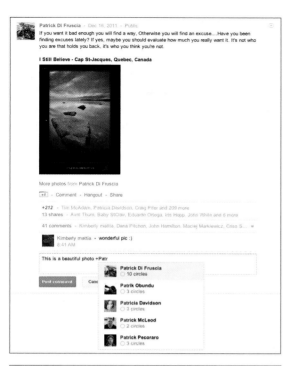

Figure 5.7 Tagging other Google+ users in a comment or in a post is one of the best ways to attempt to grab their attention. A message will be sent to their Notification box.

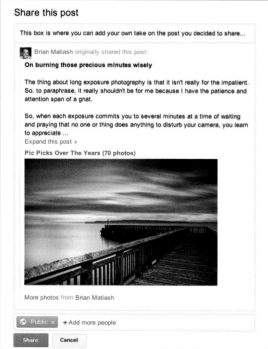

Figure 5.8 By sharing a post from another Google+ member, you are extending your possibility for interaction on the network. Although I feel that you should focus on creating your own original content, sharing a creative or intriguing post not only keeps your stream diverse, but it allows you to connect with more Google+ users in ways you might not have otherwise.

Colby's Quick Tips

When you share a post that has already been shared, only the original post is carried over. Anything that the previous sharer had mentioned will not appear. This keeps the focus on the original post creator and helps to promote the creation of original and creative content that is worth sharing.

Catherine Hall:
A Photographer's Perspective

Catherine Hall approaches her work with a fine-arts sensibility, technical mastery, and cultivated creativity. Cohost of "Best New Technology Podcast" TWiT Photo, Catherine is regularly featured in leading publications, such as the New York Times *and* National Geographic Traveler. *Her adventure-driven projects have spanned over 30 countries and have been exhibited worldwide.*

Website: *www.catherinehall.net*

Google+: *https://plus.google.com/117757565120070816446*

Q Why is it important to control your Google+ streams?

Google+ has been an incredibly inspiring network for me to share work and communicate with a vibrant community. I discover new work and talented photographers regularly, as well as get my news daily from tech and photography bloggers. To get a better experience out of the network, I organize people into various circles based on their specialty or interest. This way, I can view similar content when I click on a circle. This makes it easier for me to manage all my social media messages, keep my head above the noise, and connect more meaningfully.

Q Do you use the Block or Ignore functions in Google+?

Very rarely. Google+ has been really good to me so far, and I haven't had much need to block people. In fact, I really enjoy seeing a constant stream of phenomenal photography and art every day—in many cases from people I've never heard of prior to joining Google+. This wouldn't have been possible if I restricted interaction to a small group of people. Through my photo contests, for example, I have added large numbers of people to my circles, and I'm still in awe of the amount of high-quality work I'm seeing each time I organize a contest. This has been invaluable because it exposes me to passionate people with similar interests. Although I have to say, the Block feature is pretty well-devised; you're not only able to remove people from your circles and extended circles, but they will not be able to mention you, or view or comment on your content. Kudos to Google.

Q How important is the Google+ search box? Do you have any saved searches that you could recommend to other photographers?

I use the search field often. Before Google+ descended upon my social media life, I often

wished for a feature that allowed me to search through my posts as well as my friends' posts. The Google+ search box allows me to do exactly that and more. I can easily find users, posts, news, and relevant content from the Web by using keywords. Exactly like I do in Google.

I would recommend photogs check out my following favorite saved searches:

- TWiT Photo (of course!)
- Google+ Tips
- Canon Photographers
- San Francisco Photographers (or your local region)
- Photo Contests
- Portrait Photographers
- Photography News
- Social Media Tips
- Professional Photographers

Q Interaction is a large part of what makes Google+ so great. Why is it important to engage with other Google+ users?

If you haven't already heard, I love Google+. I'm a nerd and a workaholic, and I rarely have the opportunity to get out to socialize (*read: LOOOSer*). Google+ and its inspiring community of thoughtful, talented people are a welcome addition to my social life. Times have changed; today, people look for others with similar interests online. I enjoy being able to "talk" to my Google+ community, "hang out," and be involved in other meaningful conversations. Like every relationship, you have to contribute, whether it's socializing, providing well-considered messages, or simply saying "Hello." It is not only essential for building a community, but also for staying inspired. One of the greatest things about Google+ is that you interact with a variety of people, and they are all interested in creating a dynamic, interesting community, not merely broadcasting stock messages.

Recommending Content Through the Google +1 Button

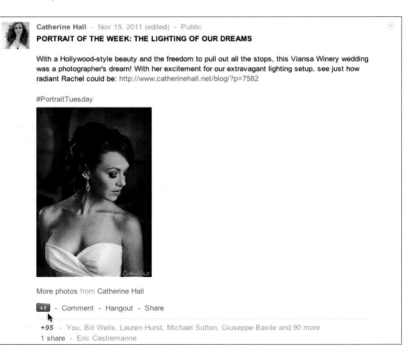 One of the biggest benefits to being actively involved on Google+ is the ability to influence search engine results. This is primarily done through the use of the Google +1 button that is found throughout Google+ and much of the Internet.

When you click a +1 button, it turns blue to confirm that you've recommended that content (**Figure 5.9**). This action carries weight because Google looks at your social connections across the Internet to see who could benefit the most from seeing the content you recommend. As a Google+ post or a regular website begins to receive a high number of +1 recommendations, it will begin to climb in Google's search results for those currently signed into their Google account (Chapter 1).

To leave a +1 recommendation on a comment or a post, simply click the +1 button found just above the Comment section on a post and just below a comment next to the time stamp.

Figure 5.9 When you click the +1 button, it turns from white to blue.

Catherine Hall - Nov 15, 2011 (edited) - Public
PORTRAIT OF THE WEEK: THE LIGHTING OF OUR DREAMS

With a Hollywood-style beauty and the freedom to pull out all the stops, this Viansa Winery wedding was a photographer's dream! With her excitement for our extravagant lighting setup, see just how radiant Rachel could be: http://www.catherinehall.net/blog/?p=7582

#PortraitTuesday

More photos from Catherine Hall

+1 - Comment - Hangout - Share

+95 - You, Bill Wells, Lauren Hurst, Michael Sutton, Giuseppe Basile and 90 more
1 share - Eric Castremanne

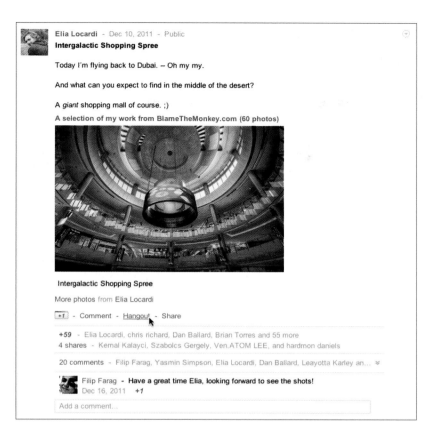

Figure 5.10 Hangouts are one of the best Google+ features. Be sure to read Chapter 8 to fully understand Google+ Hangouts.

Starting or Joining a Hangout Through a Post

You can easily start or join a hangout via a post on Google+. Located at the bottom of every Google+ post is a Hangout link. Click it to start your own hangout and invite everyone who has commented on the specified post (**Figure 5.10**). If someone else has already started a hangout through this post, you will see an invitation to join the hangout in the Comments section. This is a great way to further a conversation in a more personal and face-to-face manner.

Muting a Post

Often you'll come across a post on Google+ that has the community engaged. These posts are great ways to interact with a wide variety of people. However, if you post a comment on one of these threads, you will automatically be notified anytime anyone adds a +1 to your comment or

an individual adds a comment after yours. With 50 people commenting on a post, your notification system can quickly spiral out of control. The solution is to *mute* the post. Muting a post means that you want to stop receiving all notifications from a specific post, and you want to remove the post from your stream.

To mute a post in your stream, follow these steps (**Figure 5.11**).

1. Find the post you want to mute.
2. Click the down arrow at the top right of the post.
3. Click "Mute this post."

To mute a post from your Notification menu, follow these steps (**Figure 5.12**).

1. Click the Notification box located in the top right of your screen.
2. Click the notification for the post that you want to mute.
3. Click "Mute this post," which is located in the bottom right part of the Notification box.

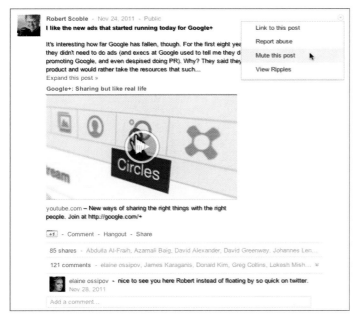

Figure 5.11 With two simple clicks, you can mute a post from your Google+ Stream.

Figure 5.12 From the Notification box, you can easily mute a post that is sending you more notifications than you want.

The Power of Search with Google+

It is no secret that as a company Google is focused on search. It has invested billions of dollars and an amazing amount of time developing advanced mathematical algorithms that help to make our lives easier. Having the most preferred search engine on the Internet, it is understandable that Google integrated many of its search features into the Google+ network.

Searching for Content

Located in the middle of the Google+ navigation bar found at the top of every page is the Google+ search box (**Figure 5.13**). Here you can search for a Google+ user, a specific post, or a broad topic. As you begin to type in the search box, Google+ instantly displays profiles and pages that attempt to match your search terms (**Figure 5.14**). A search on my Google+ account for "Colorado," for example, brings up two user profiles and five Google+ pages, all with Colorado in their names. Although this feature works well if you are looking for an individual or a business, it does not help you search for content. To sidestep selecting one of the displayed profiles, simply press Enter to perform a

Colby's Quick Tips

The Google+ search bar is a great way to find one of your old posts. Simply type in whatever keywords you remember, and then change the search filters to "Google+ Posts" and "From You."

Figure 5.13 The Google+ search bar is located at the top of every page on Google+. Use it to find interesting content, other Google+ users, and even content you published months ago.

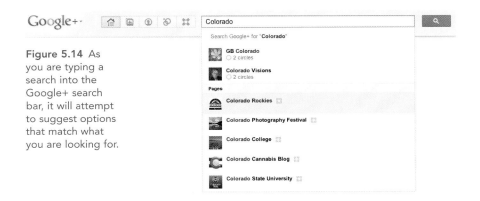

Figure 5.14 As you are typing a search into the Google+ search bar, it will attempt to suggest options that match what you are looking for.

standard search. Once on the search page, you'll notice a similar layout to your main stream, but this one has a few new features.

The content stream on the Google+ search page operates in real time. This means that while you are looking at the stream, any new content that was added to the network since you searched will continue to scroll through your stream automatically. To pause the stream so that you can inspect the content more closely, simply click the Pause button located at the top of the stream. Note that the Pause button only becomes visible if more content is published to Google+ that pertains to your search.

Search filters

Included in the Google+ search function is a set of fairly advanced filters that allow you to more accurately pinpoint your search results. These filters are located near the top of the search page and are divided into three sections: Type of Content, Source of Content, and Location (**Figure 5.15**).

The Type of Content filter includes the following options:

- **Everything.** Anything on the entire Internet
- **People and Pages.** Only individual profiles and pages on Google+
- **Google+ Posts.** Only content published on Google+
- **Sparks.** Trending content found on the Internet (see the "Trends" section next)
- **Hangouts.** Search Google+ Hangouts descriptions

The Source of Content filter includes the following options:

- **From everyone.** Content from everyone on Google+
- **From your circles.** Content only from people you have in your Google+ circles
- **From you.** Only content you have published on Google+

Colby's Quick Tips

To search for local photographers to connect with, simply type the name of your location and the word "photographer" into the search box. Be sure to change the search filter to People and Pages. The search feature on Google+ will comb through Google+ profiles to find people who live in your area and indicate that they are interested in photography in their bios.

Figure 5.15 All three types of search filters are found just below the Google+ search bar.

Colorado Photographer

Save this search

Everything ▾ From everyone ▾ From Everywhere ▾

The Location filter includes the following options:

- **From Everywhere.** Content from any location on the planet
- **Specified Location.** Content from a specific location, such as Chicago or Denver.

Below these search filters you'll find two additional filter options:

- **Best of.** Content that has the most relevance to your initial search.
- **Most Recent.** Content that was published most recently.

Trends

Located on the right side of the search page is a section called Trends (**Figure 5.16**). This section is meant to reflect the most popular subjects on Google+. When you click one of the Trend topics, a page appears showing you all of the most recent content published from Google+ users involving the selected subject.

Although this section hardly ever relates to photography, it can be helpful to gather information regarding current events in the news on a variety of topics.

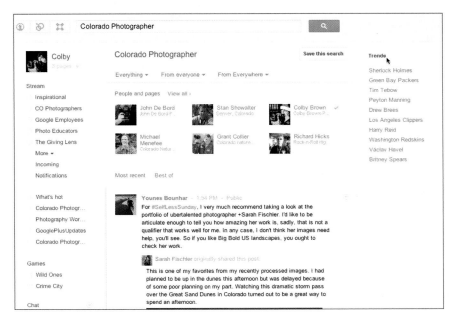

Figure 5.16 Trend topics are found on the right side of the Google+ search page. These topics are constantly changing based on the number of people talking about them at any given time on the network.

Saved searches

If you are constantly performing the same Google+ search over and over, you'll love Saved Searches. Utilizing this feature allows you to easily repeat a Google+ search with ease.

After performing a search for any term, you'll notice a button labeled "Save this search" just to the right of the displayed search criteria (**Figure 5.17**).

Click this button to add the current search to a list found in the sidebar on the left located just under your stream filters. You can identify these saved searches by the magnifying glass icon located to their left (**Figure 5.18**). If you ever want to perform the same search again, just click the appropriate link and Google+ will bring up the most recent content involving your search.

As a photography instructor, I am always looking for ways to connect with photographers in my region. By saving the search "Colorado Photography," I can easily find local photographers and individuals who are interested in photography in my home state. In principle this can work for nearly any topic you might find interesting. Do you like black-and-white photography or perhaps images from New Zealand? Are you looking for travel advice for visiting Nepal? Simply save a search and revisit it as many times as you want.

Figure 5.17 By utilizing the "Save this search" feature on Google+, you can maximize your time looking for specific content on Google+.

Figure 5.18 You can create as many saved searches as you like, but only five will display by default until you click More.

Hashtags

The Internet has been utilizing hashtags for years, but hashtags were mostly made popular by another social network, Twitter. Basically, they are simplified keywords that allow you to find content on the Internet. However, a number sign (#) precedes them to indicate they are in fact a hashtag. Although you do not have to use hashtags when utilizing the Google+ search bar, including them in your posts can be beneficial (**Figure 5.19**). On Google+, a hashtag is automatically converted to a hyperlink that when clicked will link you to search results for the specified hashtag.

Colby's Quick Tips

Hashtags can provide great opportunities to group similar content, such as images from an event. You can even create your own hashtag, such as #yosemite2011 and have all those who went on that trip use the same hashtag on their image posts. When you then search for #yosemite2011 in the Google+ search bar, you'll find all relevant content easily.

Figure 5.19 By adding hashtags to your images, you can easily share in community projects, such as themed days. Many photographers on Google+ participate in these daily events, and by participating, you have a good chance of interacting with others who join in. See Chapter 6 for more information on theme days.

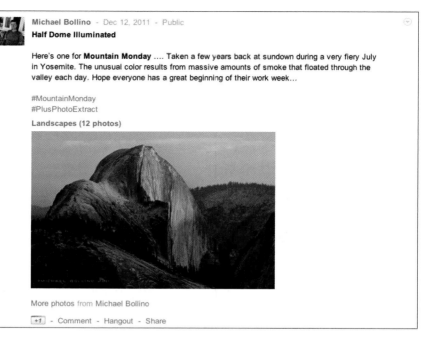

How Does Google+ Deal with Spam?

With any social network that has a growing user base and that has attracted a lot of attention, spammers are sure to follow. The reality is that although we may personally have disdain for such practices, they do exist for a reason, and someone somewhere is making money on those practices; otherwise, spam would cease to exist.

Google+, however, does take spam very seriously and offers a handful of different solutions to combat the annoying experience of dealing with spammers.

Reporting Spam

As Google+'s first line of defense, it is its users who are responsible for finding and reporting any spam they come across. Three different aspects of Google+ can be reported as spam: a Google+ account, a post, or a comment.

Google+ account

There may come a time when you realize that an individual or business is violating the rules of Google+, and you'll need to report that account. On the announce page in question (profile or page) at the bottom of the left sidebar is a "Report this profile" link. By clicking this link, you can report the account for the following reasons: spam, nudity, hate speech or violence, copyright infringement, impersonation, or having a fake profile.

Post

If you find a post from an individual that you feel is spam or that has violated any of Google+'s rules, you can easily report the post in question.

To report a post, follow these steps.

1. Click the down arrow located in the top-right corner of every post on Google+.

2. Choose Report Abuse (**Figure 5.20**).

3. Report the post as spam, nudity, hate speech or violence, or copyright infringement.

Figure 5.20 By clicking a post's drop-down menu, you have access to a few hidden features, such as muting a post and reporting it as a violation against Google+'s rules.

Colby's Quick Tips

It is important to note that reporting an account, post, or comment only flags the possible infringement for review; it does not automatically remove it from Google+.

Comment

The most common form of spam is a comment on a post from another Google+ member. If you want to report an individual comment as spam, simply click the gray flag icon that appears as you move your mouse over the comment in question (**Figure 5.21**). By doing so, you will flag the comment for review by Google and bring the possible violation to the attention of the post's creator.

If you are the creator of a post with flagged content, you also have the ability to delete any comment in the comment thread. Located next to the gray flag is an "x" icon that signifies the deletion of that specific comment. This is handy when dealing with spammers. I will first flag the comment, and then delete it. As a result, the Google+ system will get better at auto detecting spam in the first place.

Auto Detecting Spam

Google+ has a comment spam moderation system in place to help actively combat spam. It works to detect spam, even before you see it appear in one of your posts.

If spam is detected as a comment on a Google+ post, the system does the following:

- Automatically marks the comment in question for review.
- Allows only the creator of the post to see the questionable comment.
- Creates a gray overlay over the possible spam, allowing the post's creator to identify it.
- Gives the post's creator a choice to remove the comment or approve the comment and restore it to the post.
- Doesn't allow the creator of the comment in question to know that it has been marked as spam.

Block vs. Ignore

At some point, you may want to totally disconnect from an individual on Google+. You have two main options when it comes to distancing yourself from that person: Block or Ignore; one is more severe than the other.

Block

When you choose to block someone, you will break *all* contact with that individual or Google+ page. It is the most severe action you can take to separate from the other person.

When you block someone

- You won't see that person's content in the stream or in the Incoming section (although you will remain in that person's circles).
- The individual will be removed from your circles.
- The person will be removed from your extended circles, even if you have mutual connections with other individuals.
- The person won't be able to comment on any of your content that was posted after the individual was blocked.
- The person won't be able to view content shared with your circles (although the individual may still see content you post publicly).
- The person won't be able to tag/mention you in a post or comment, because the system will not allow it to happen.

How do you block someone? Well, there are multiple ways in which you can block someone on Google+.

From a profile:

1. Go to the individual's profile.
2. On the left sidebar click Block [*person's name*] (**Figure 5.22**).
3. Confirm that you want to block this individual.

From your Circles page:

1. Go to the Circles page on Google+.
2. Highlight the individual you want to block.
3. Click the More button located just above the profile thumbnails.
4. Choose Block (**Figure 5.23**).
5. Confirm that you want to block this individual.

Figure 5.22 To block a Google+ user, visit the user's profile and click the Block [*person's name*] link, which is always located on the left sidebar of the page.

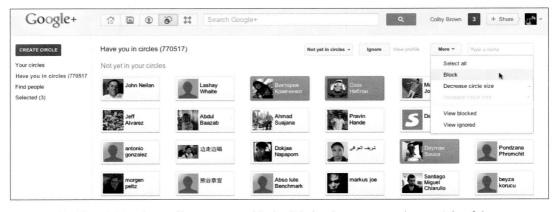

Figure 5.23 After clicking the profile you want to block, click the down arrow at the top right of the screen and choose Block.

From one of the individual's posts:

1. Locate a post from the individual you want to block.
2. Click the down arrow located in the top-right corner of the post.
3. Choose "Report abuse" from the options.
4. Select Spam and click the Submit button (**Figure 5.24**).

Figure 5.24 This small pop-up window appears after you click "Report abuse."

From a hangout:

1. Hover your mouse over the individual's video feed.

2. Click the Block link that appears.

3. Confirm that you want to block the person in question.

Blocking an individual in a hangout is slightly different than blocking using any of the other options. Here is how blocking works in hangouts:

- If you block someone while in a hangout, you will not be able to see or hear the individual for the remainder of the hangout. However, the person will not be removed from the hangout automatically.

- Everyone will see that you blocked someone, including the person you blocked.

- You will not be allowed to enter a hangout if someone you have blocked is already in the hangout.

- Anyone you block will not be able to enter a hangout that you are currently in.

Ignore

Using the Ignore feature is much less severe than blocking an individual, but it will still provide some distance between you and the ignored individual.

When you ignore a person:

- That person will be removed from the list of people who have added you to their circles on your Circles page.

- Any new content from the individual will not appear in your Incoming stream, and any content that person has already shared will be removed from your streams.

- You will not receive a notification if the ignored person mentions you in a post or a comment on Google+.

Colby's Quick Tips

To view a list of everyone you have blocked or ignored on Google+, head to your Google+ Circles page. Click "More actions" in the top right of your screen, and choose View Blocked or View Ignored.

Figure 5.25 Ignoring people through the Notification box is not the best choice in my opinion, because it does not give you the chance to learn about the individual or see what content that person has published on Google+.

There are multiple ways to ignore someone on Google+.

You can ignore someone through Notifications.

1. Click your Notification box.
2. Click a notification that shows "Added you on Google+."
3. You can either add the individual to your circles or ignore that individual.
4. Click Ignore (**Figure 5.25**).

You can ignore someone from your Circles page.

1. Head to your Circles page on Google+.
2. Click "People who've added you," which is located in the left sidebar.
3. Highlight the individual you want to ignore.
4. Click the Ignore button just above the profile thumbnails (**Figure 5.26**).

Figure 5.26 Ignoring Google+ users through the Circles page allows you to select multiple accounts at once to ignore.

+1

Publishing Your Photographs and Other Content

One of the biggest reasons for photographers to get involved in any online network is to share their artwork with others. Because of the advances in digital technology, the fact that personal computers and smart phones are more affordable than ever, and the increasing popularity of online networks, you have the opportunity to reach a wide variety of individuals from all over the globe in ways that were not possible ten years ago. Now that you've spent some time getting to know Google+, it is time to start sharing some content.

In this chapter I'll walk you through the process of creating a post, show you how to upload your images and videos to the network, and give you some examples of how to increase the amount of interaction you receive on Google+.

Publishing Content to Google+

The center point for all interaction on Google+ is content. With over 100 million Google+ members, you can bet that at any given moment someone is sharing information on the network that was heard, created, read, or seen (**Figure 6.1**). Although I discussed the importance of sharing other Google+ members' content with your followers in Chapter 5, nothing beats creating your own posts for others to engage with. Sharing a very popular post that is being passed around the network is not nearly the same as being the original creator of the post that is being shared. If your goal is to build a following and establish yourself as a photographer on Google+, sharing your own content is key.

Figure 6.1 When you create your own content, you allow more people the opportunity to engage and interact with you. Jay Patel received 114 +1's, 10 shares, and 47 comments from this post that he created and published.

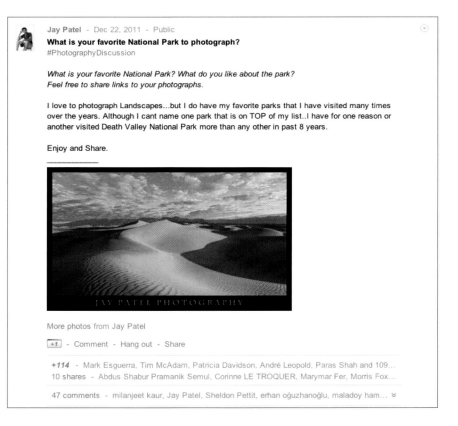

Creating a Post

To create a post on Google+, you must utilize the Share box, which is found at the top of any Google+ Stream page as well as in the Google+ navigation bar (**Figure 6.2**) on every page on the network. It is here that you can share text, a link, a movie, a photo, and even your GPS location.

To begin creating a post to share, click one of the previously mentioned Share boxes. The Share box in either location displays the same sharing features and the same screen (**Figure 6.3**).

The blank space in the middle of a Share box is where you can write in any relevant text to include in your post. Five small icons located in the lower-right corner of the Share box represent the various items you can include in your post (from left to right):

- **Photos from your phone.** With the Instant Upload (Chapter 9) feature turned on for your mobile phone or tablet, clicking this icon allows you to easily add to a post images that you have taken on your mobile device.

Figure 6.2 The Google+ Share boxes are your main source for creating and sharing content on Google+. They are very easy to use and are visible on every page throughout Google+, allowing you to share content no matter what you are doing.

Figure 6.3 Once inside the Google+ Share box, you have the ability to easily share text, an image from your mobile device, a photo from your computer, a video from YouTube, a link to another website, and your current location.

- **Add photos.** Clicking the green camera icon allows you to add photos to your post from your computer, create a new photo album, or select images from your mobile device.

- **Videos.** Clicking the box with the red arrow icon allows you to upload a video from your computer, share a YouTube video, upload a video from your mobile device, or even record a quick video broadcast to share with your followers. You can share only one video per post via this feature.

- **Web links.** Clicking the paper clip icon allows you to share a link in your post. Any visible images and any metadata description on a supplied link can appear as a thumbnail teaser, giving viewers a glimpse of what the link is about. You can share only one link per post via this feature.

- **Your current location.** Clicking the red pinpoint icon allows you to share your current location. Google attempts to identify your location for you, although it is not always 100 percent accurate from a web browser compared to a mobile device (Chapter 9) with GPS functionality.

At the bottom of the Share box you can determine who to share your post with via the "Share to" box (**Figure 6.4**). Google+ gives you full control over sharing your content with whomever you choose. If you want to share an image with your family or past clients only, select your Family or Clients circle so that those in the circle are the only ones who can view the post. If you click the "+Add more people" link, a menu appears listing your first five circles, a link to see all of your circles, or the options to select any of the standard Google+ circles (**Figure 6.5**):

- **Your circles.** This option makes the current post visible to everyone you have circled, by default. You can, however, customize which circles you wish to include in "Your Circles." Select "Your Circles" and use your mouse to hover over it inside your "Share to" box. Then click "Customize."

- **Extended circles.** This option makes the current post visible to everyone in your circles plus everyone in their circles.

- **Public.** This option makes the current post visible to everyone on Google+ as well as the entire Internet.

Figure 6.4 The "Share to" box gives you full control over who you want to share the current post with. You can share a post privately with just one other person, to a group of individuals in a circle, or with everyone on Google+.

Figure 6.5 This menu makes it easy for you to select the circle you want to share your post with. Organizing the order of your circles so that those you interact and share with the most are first (Chapter 4) allows you to quickly and easily share posts with just those circles.

Figure 6.6 When sending a private message, I highly recommend that you type the words **private message** at the top of the post so that the Google+ users you are sending the post to know that it is private and not to be shared with others.

In the "Share to" box, you can also share a post privately with one or more Google+ users. To do this, click in the box and begin to type in the name of the Google+ user you want to share your post with (**Figure 6.6**). To make the process easier, Google+ automatically provides a list of suggestions based on who you have circled and interacted with on the network.

Editing a Post

As a photographer, I pride myself on not only the images I take, but also the stories I write about my experiences; however, I happen to be horrible at spelling. On other online networks, I've often cringed after reading one of my posts, knowing full well that I don't have the ability to edit what I've written. With Google+, I don't have to worry.

To edit one of your posts, follow these steps.

1. Click the down arrow located in the top right of the post in question.

2. Choose "Edit this post" from the menu (**Figure 6.8**).

3. Make adjustments to your post (you can even fix a web link).

4. Click the Save button at the bottom of your post.

Google+ Snippets

The integration of other Google products and services into Google+ is vital to the sustained growth of the network. Currently, Google allows you to share *snippets* of content from Google Maps, Google Books, Google Offers, and Google Product Search directly to Google+ from within these separate services. This is done through the Google+ navigation bar, which is slowly being rolled into all other Google products and services. For example, you could share driving directions from Google Maps directly with a friend or customer on Google+ (**Figure 6.7**).

To share a snippet from Google Maps, follow these steps.

1. Visit Google Maps at http://maps.google.com, or move your mouse over the Google logo in the Google+ navigation bar to display the Google menu and click the Maps icon.

2. Click the Get Directions button just below the Google logo in the top left of your screen.

3. Fill in the point A and B boxes with locations of your choice, and click the Get Directions button.

4. Click the + Share box located at the far right of the Google+ navigation bar.

5. Notice that the driving directions are already in the Share box. Add any text you want to add to the post, and then select who you want to share your post with.

6. Click the Share button.

Currently, the snippets feature works only with Google Maps, Google Books, Google Offers, and Google Product Search.

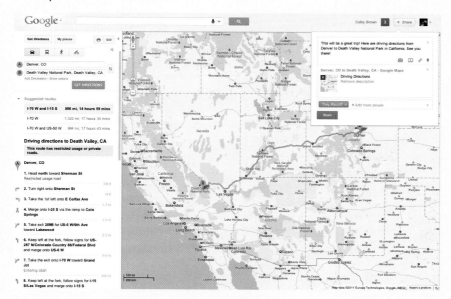

Figure 6.7 As Google continues to integrate more and more of its products and services, the ability to find and share content will continue to grow. With Google Calendar, Google Music, and many other Google products, the possibilities for integration are endless.

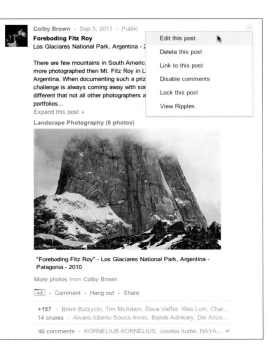

Figure 6.8 You can always edit any post you've published on Google+, fixing any mistakes or even updating the post if new information comes to light after you've shared it. The one post you cannot edit is a circle that you've shared (Chapter 4).

Controlling How Others Can Interact with the Content You Publish

Often, when you reshare someone's post or you send private messages to other Google+ members, you'll want to exercise more control over how people can interact with what you are sharing. Google+ allows you to lock your post so no one can reshare it and to disable comments so that no other Google+ user can comment on the post.

You can enable either of these features in two ways:

- Click the down arrow located at the far right of the "Share to" box when first creating your post (**Figure 6.9**), and choose "Lock this post" or Disable Comments.

- Click the down arrow located in the top-right corner of your post that has already been published and choose "Lock this post" or "Disable comments" (**Figure 6.10**).

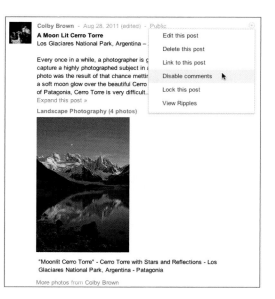

Figure 6.9 The best way to implement control over the interaction of your posts is to select the corresponding setting before the post is published.

Figure 6.10 After you have published a post, the only way to enable these control features is by using the menu in the post.

Tracking Your Post

Have you ever published a very creative or engaging image or article on the Internet and watched as it was spread throughout Facebook, Twitter, Tumblr, and any of the other online networks? Wouldn't it be great if you could follow the path of interactions while your creation is being spread across the network? With Google+ Ripples you have that ability.

Google+ Ripples displays an interactive graphic of public shares of any post on the network, as shown in **Figure 6.11**.

To view the ripples of a post, follow these steps.

1. On the post in question, click the down arrow in the top-right corner of the post to display a menu.

2. Choose View Ripples.

On the Google+ Ripples page you'll find lots of statistical information:

- **Public shares and comments.** In the main window you'll see a graphic representation of the public shares of the post. People who have shared the post will be displayed with their own circles. Inside those circles will be people who have reshared the post from those people (and so on). The size of the circles is representative of a person's influence; so those with many followers will have larger circles, showcasing their potential influence over others.

 The comments added by users when the post was shared will appear in the sidebar at the right. As you zoom in and out of the circles, you'll

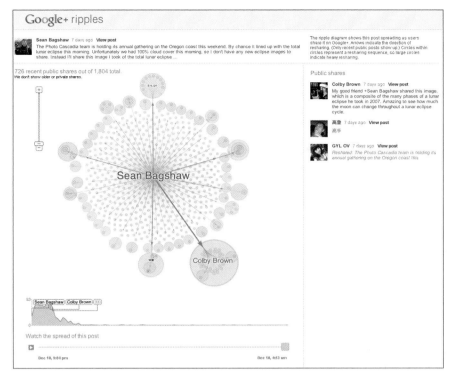

Figure 6.11 Google+ Ripples represents an excellent way to track a post as it is shared throughout the network. If used correctly, it can show you which individuals on Google+ can help spread other content you publish because they have a larger sphere of influence.

Figure 6.12 Ripple statistics can help you identify your influencers easily and provide other data that show how far reaching the post became.

see different comments from various individuals. You can also view the comments people made on their reshare by hovering your mouse over their names in their representative circles.

- **How a post was shared over time.** At the bottom of the Ripples page is an animated graph that shows how the post was shared over time. You can even click the Play button under the graph to watch how the post was shared across the network.

- **Post statistics.** At the bottom of the Ripples page you'll find all the post statistics (**Figure 6.12**). You can determine who helped share the post the most, view statistics for how the post was shared, and even see the native languages in which the post was shared.

Uploading and Sharing Photos to Google+

When it comes to uploading photos and videos to Google+, you have more options than just using the Share box mentioned previously. Although the Share box is convenient and always just a click away, its biggest drawback is the fact that all of your photos shared directly to a post are automatically moved into your "Photos from posts" photo album. As a photographer, I like to keep my photography work organized on my work computers and online. The two best places to upload new images to Google+ that you want to share are through the Google+ Photos page and on your Google+ profile.

From the Google+ Photos Page

To access the Google+ Photos page, click the Photos icon in the Google+ navigation bar (**Figure 6.13**). The default section of thumbnail images you'll see will be "Photos from your circles" (**Figure 6.14**). On the Google+ Photos page you have a multitude of options for uploading and sharing images on Google+.

Uploading a new photo

To upload and share a new photo (or multiple photos) to Google+, follow these steps.

1. Click the Upload New Photos button located in the top-right area of the Google+ Photos page.

2. Decide if you want to create a new album to store your image in or if you want to add it to an existing album. Both options are located at the top of the "Upload and share photos" window that appears (**Figure 6.15**).

> **Colby's Quick Tips**
>
> Google+ allows you to upload photos up to 2048 x 2048 pixels in size. Any images larger than those dimensions will automatically be resized to 2048 pixels on the photo's longest edge. Google+ also strips all metadata if it has to resize your image, including copyright information.

Google+ ⌂ 🖼 ① 🎮 ⤢ Search Google+ 🔍

Photos

Figure 6.13 The Google+ Photos icon on the navigation bar is represented by a photo frame with a green mountain in it.

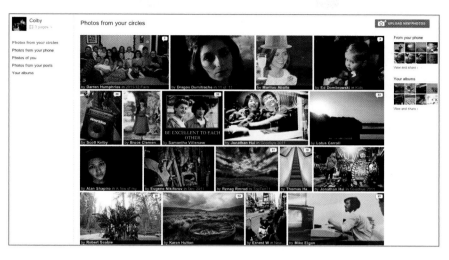

Figure 6.14 The Google+ Photos page allows you to not only upload and share your own images, but view photos that others have published to Google+ as well. It is the access point for viewing, sharing, and organizing photos on Google+.

Upload and share photos ×

Upload Album name: January 1, 2012 or add to an existing album

From your phone

Drag photos here

Or, if you prefer...

Select photos from your computer

Cancel Create album

Figure 6.15 The "Upload and share photos" window appears when you click the Upload New Photos button in the main section of the Google+ Photos page.

Drag photos here

Or, if you prefer...

Select photos from your computer

Add photos

3. Either drag the photo(s) from your desktop to the middle of the "Upload and share photos" window or click the "Select photos from your computer" button to choose the images you want to upload.

4. Edit the caption of the photo(s) you selected to upload by clicking in the area just below the image thumbnail (**Figure 6.16**).

5. Click the "Add photos" button in the bottom-right corner of the window when you are ready to proceed.

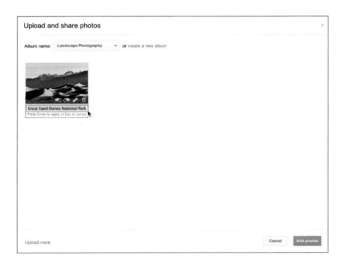

Figure 6.16 Editing the caption of your images is important because Google scans the captions when performing searches in Google+ and on the Internet (if you share the image publicly).

Figure 6.17 Adding backstory and all relevant image information, such as ISO, shutter speed, and aperture, to the body of your post will help other Google+ users connect with your image. Telling the story behind the image might elicit more interaction on the photos you publish to the network.

6. A Share box appears allowing you to share the image you just uploaded with other users on Google+ (**Figure 6.17**). Add any relevant text or backstory to the body of the post and be sure to select which circles or individuals you are sharing the post and image to. When you are ready, click the Share button in the lower-left corner of the Share box window.

Sharing a photo from your phone

If you have the Instant Upload feature turned on on your Android mobile device (not compatible on iPhones or iPads), you can easily add images you took on your phone or tablet to a Google+ photo album or a post to share with your followers on Google+.

To share a photo from your mobile device, follow these steps.

1. Click the "Photos from your phone" link located in the left sidebar of the Google+ Photos page (**Figure 6.18**).

2. The photos on your "Photos from your phone" page are divided into separate sections that represent different days that the photos were taken and uploaded on your mobile device. Click the photo(s) you want to share. A red border appears around the selected photos (**Figure 6.19**).

Figure 6.19 You can select as many photos as you want to share or add to a Google+ album.

Figure 6.18 The "Photos from your phone" link is the second option from the top in the left sidebar on the Google+ Photos page, just below your profile thumbnail.

3. Decide if you want to share the photo(s) immediately (the selected images will automatically be moved to your "Photos from posts" Google+ photo album) or if you want to add them to a new or existing photo album and then share the photo(s) with your followers. Click the Share button if you want to share instantly or the "Add to album" button if you want to organize the photo(s) into albums first (**Figure 6.20**).

4. If you click the "Add to album" button, a window appears allowing you to add a caption to the photo(s) as well as choose in which photo album the selected photo(s) will be placed, whether it is a new album or an existing one (**Figure 6.21**). When you are ready, click the "Add to album" button in the lower-right corner of the window.

5. A Share box appears allowing you to share the selected photo(s) with your followers.

Figure 6.20 The Share button and "Add to album" button are found at the top of the "Photos from your phone" page.

Figure 6.21 Don't forget to add a caption to your photo before you choose which folder to place it in.

Colby's Quick Tips

Organizing your photos in the correct folders will allow you and your followers to find them easily in the future.

Sharing an image you have already uploaded

There might be a time when you want to reshare a photo that you've already uploaded and shared with your followers on Google+. Although this is an easy process on Google+, you are not in fact sharing your previously uploaded photo; instead, you are creating a duplicate of it on Google+. Your current comments and +1's will not transfer over, so keep that in mind.

To share an image that you've already uploaded to Google+, follow these steps.

1. Click the "Your albums" link (**Figure 6.22**) in the left sidebar of the Google+ Photos page. (You can also access this section from your Google+ profile.)

2. A series of thumbnails appears that represents the various albums you have on Google+. Click the album that contains the photo you want to reshare, and then click the specified photo.

3. A lightbox containing the selected photo appears, allowing you to view the image with a black background. Click the Share button in the bottom-right corner of the window (**Figure 6.23**).

4. A Share box appears allowing you to share the selected photo with your followers.

Figure 6.22 The "Your albums" link is located at the bottom of the left sidebar, just below your Google+ thumbnail profile photo.

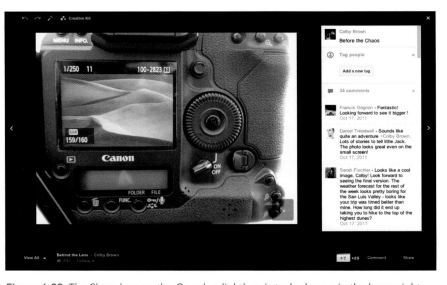

Figure 6.23 The Share box on the Google+ lightbox is tucked away in the lower-right corner of the window.

From Your Google+ Profile

On your Google+ profile you'll notice a Photos tab (discussed in Chapter 3). From the Photos tab you can upload a new photo and share an existing photo on Google+ with your followers, just as you can from the Google+ Photos page.

To upload a new photo or share an existing photo, follow these steps.

1. Access your Google+ Profile page by clicking the Profile icon in the Google+ navigation bar (**Figure 6.24**).

2. Click the Photos tab (**Figure 6.25**).

3. To upload a new photo, click the Upload New Photos button just above the thumbnail images that represent your photo albums, and then follow steps 2–6 in the "Uploading a new photo" section earlier in this chapter.

Figure 6.24 The icon for your Google+ profile is a circle with a blue person in its center.

Figure 6.25 The Photos tab in your Google+ profile is in the gray bar located in the middle of your profile.

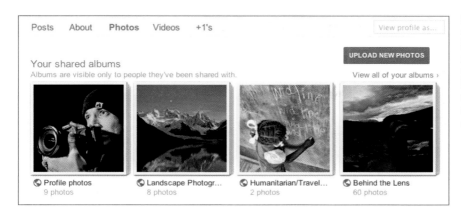

Figure 6.26 From your Google+ profile, you can access all of the images you've uploaded by clicking the Photos tab and then clicking "View all of your albums."

4. To share an existing photo with your Google+ followers, click the album that contains the image you want to share. If you do not see the album in question, click the "View all of your albums" link just below the Upload New Photos button (**Figure 6.26**). When you've found the correct album, select the photo you want to reshare, and then follow steps 2–4 in the "Sharing an image you have already uploaded" section earlier in this chapter.

Ways to Increase Interaction

When you first join an online network, it can seem daunting to attempt to build a following or even get any interaction on the content you publish. This is a common problem on networks like Facebook where you will only receive a few "likes" on anything you share.

Although the Google+ network thrives on interaction and has a growing and energetic photography community, it doesn't mean that you will not have to put in some effort to get the most out of your time spent there. A very common misconception, even from seasoned professional photographers, is that simply sharing your photographs online—no matter how beautiful they may be—is enough. Instead, it is just the beginning. To help you increase the interaction you receive on Google+, you should think about creating original content, schedule your posts to coincide with high-traffic times on the network, join a theme photo day, or even submit the images you upload on Google+ to a third-party website that showcases talented photographers on its network.

Uploading a Video to Google+

As mentioned in the "Creating a post" section earlier in this chapter, you can upload videos directly to Google+. Although you can upload and add a video to a post using the Share box, you can also do so via your Google+ profile.

To upload and share a video from your Google+ profile, follow these steps.

1. Click the Videos tab in the middle of your Google+ profile (**Figure 6.27**).

2. Click the Upload New Videos button on the right side of your profile on the Videos page.

3. Follow steps 2–6 in the "Uploading a new photo" section earlier in this chapter.

You can upload an unlimited number of videos, but each video cannot be longer than 15 minutes or larger than 1080p in resolution.

Figure 6.27 The Videos tab in your Google+ profile contains all of the videos you have uploaded directly to the network but none of the videos that you have uploaded to Google's YouTube service.

The Power of Original and Creative Content

As discussed in Chapter 2, there is no substitute for creating original and creative content and sharing it on any online network. Resharing posts created by other Google+ members is important, but wouldn't you rather be the one sharing a post or have hundreds or thousands of other Google+ users sharing your post (**Figure 6.28**)?

You must realize that on any online network, nearly all users want to have their voices heard. Even with Google+, which has over 60 million users (a fraction of Facebook's 850+ million), that's a lot of people vying for your attention to the content they create and share. Photographers are no different. Many love sharing their work as much as they love the process of

Mike Shaw · 5:29 AM · Public

G+ Wallpapers

Hi Googlers, did you miss me?

Sorry I have not been around much for the last few days but with the holidays and having to work through New Year (I was asleep by 23:00hrs last night) I have had little time to do much, I am once again very behind on here but I will play catch up when I get some time off (I am in work as we speak) but I wanted to jump on to share all the wallpapers I have created exclusively for G+ as I have finally managed to get them moved to their own folder in my gallery. Its a way of simply saying thank you for your support over the last six months or so on here and I hope to be able to provide more wallpapers in the future should you want them.

I hope you all had a wonderful party yesterday and I hope the New Year brings you all that you need.

Wallpapers (6 photos)

More photos from Mike Shaw

+1 · Comment · Hang out · Share

+464 · Jerry Kiesewetter, Wendy Walker Cushing, Younes Bounhar, Sandra Parlow, David Or...

105 shares · Davor Maksimović, Eva Mari Tagudina, Jay Jay Jaruwan Viwatbutsiri, John Arn...

82 comments · KAT STARCHILD, Susan Gabriel, Gowthami Sravani, Jonathan Behar, Jad... ⌄

Figure 6.28
Photographer Mike Shaw is known for the compelling content he publishes and shares on Google+. He puts a lot of thought and heart into his posts, and the high level of interaction and engagement he gets from other Google+ users is a testament to being creative and sharing personal pieces of yourself via your photography.

creating their photographs. However, too often I see photographers on Google+ making the same mistakes. They take a beautiful photo, share the image with no background information, and then sit and wait for the flood of comments, shares, and +1's that never come. Why? Most of the time it is because the post doesn't stand out from the crowd.

Try to think outside the box. For example, imagine you and a group of nine other photographers are visiting a beautiful glacier. Everyone is standing right next to each other taking the same photograph. Looking at each of the ten images, how difficult is it for your image to stand out if each photo looks the same (**Figure 6.29**)?

To separate your posts from the rest of the traffic on Google+, you need to mix it up. Don't just share a photograph; share the backstory of what it took to capture the image. Don't just post about your photography work; tell everyone about you or your family (**Figure 6.30**). If you want to hold a contest to give away some of your prints, engage with the community and don't make it about you. Be creative. Be original. Be you.

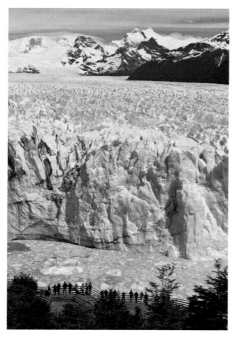

Figure 6.29 I took this photograph while at the Perito Moreno Glacier in southern Argentina. Although the glacier is certainly a sight to see, it always confused me as to why everyone at the bottom of the image seemed to want to stand right next to each other and capture the same shot.

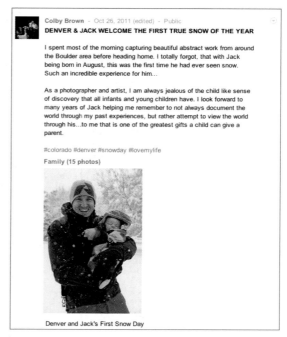

Figure 6.30 In August 2010, my wife and I welcomed our first son, Jack, into this world. Sharing my adventures of being a new parent with my Google+ circles has allowed my followers to get to know me in a more personal way. Social networking is about personal interaction, not just marketing pitches.

Grayson Hartman:
What Google+ Means to You

Grayson spent his summers as a wildland fire-fighter, a Hotshot with the USDA Forest Service, from his Cal Poly SLO years through 2010. He always carried a camera in his shirt pocket so he could capture the stunning images that fueled his passion. In 2009, Gray purchased his first professional DSLR camera. It redefined his existence. Since then, as a self-described adventure seeker, he has documented his work and travel adventures, continually endeavoring to attain an ever-increasing level of mastery and honing his uniquely sensitive style of digital photography.

Website: *http://grayhartphotography.com*

Google+: *https://plus.google.com/111674748486766258557*

Essay

Imagine a place for photographers to go where images flow in an endless stream of information, inspiration, and education. This community of people is the solid bedrock on which the stream flows. And the conversations, +1's, comments, and shares are the web of communication that tie everyone together, amateurs and pros alike. This place is Google+.

Google+ is an inspirational and dynamic interactive community for novice and professional photographers. For aspiring and budding photographers, it is indispensable as a tool and arena from which point critique and exposure can take place. Professionals can use Google+ to share images and indispensable knowledge or to network with relative ease, making communication possible with amateurs as well as other seasoned photographers.

In true Google fashion, the Google+ platform is clean, user friendly, and intuitive. Images look great in their native thumbnail size, and look even better in their black box.

Google+ is great for beginners, too—add some photography circles, find some tutorials, post a photograph, and ask for critique. If you don't know what to post, there are daily photography themes to get the ball rolling.

Google+ is the social networking place for photographers.

Scheduling Your Post on Google+

One of the most overlooked aspects of social networking is the fact that it happens on a global scale. Although the bulk of users on Google+ might be in the United States or Europe, the network certainly reaches the far corners of the earth. One of the first questions I ask those who come to me for advice on how to get more people to interact with their posts is, "At what time of day do you publish your content?" You see, social marketing is still at its core a numbers game. That doesn't mean that quantity overshadows quality but simply that numbers do still play a role. If you publish a post at 3 a.m. on a Sunday night, do you think you would get the same level of interaction on your post as if you published it at 1 p.m. on a Wednesday? For people to see your posts, they have to be on Google+. One of the challenges of Google+ is dealing with the dynamic nature of streams. Unlike Facebook, where you have a stagnant wall, your streams are constantly moving, often at a fast pace. This means that the life of anything you publish is often short lived. Therefore, you should schedule your posts so you are publishing during high traffic times on the network for the Google+ users that you want to reach.

Unfortunately, there is no magic formula that I can give you to maximize the timing of your posts on Google+. However, the best piece of advice I can give you is to study the posts you publish to Google+ over the span of a month. Take into account the time of day, day of the week, and any holidays that occur when you're looking at your numbers. Not everyone on Google+ has the same number of followers from the same countries, so results will vary. If you find that more of your followers are from France or the west coast of the United States, you might want to think about adjusting the time you publish each day to compensate for the time difference between your location and that of your followers.

In my experience on Google+, I receive the most interaction during these times:

- 8 a.m.–9 a.m. on any weekday
- 12 p.m.–2 p.m. on any weekday
- 6 p.m.–7 p.m. on any weekday
- 6 p.m.–8 p.m. on Sunday night
- Mid afternoon on a holiday

(I live in Denver, Colorado, which is Mountain Standard Time or UTC/GMT –7 hours.)

Take Part in a Daily Photo Theme

One of the most creative examples of getting more interaction on your Google+ account is to join a daily photo theme. Google+ members have created days of the week that correspond with a specific subject. Daily photo themes are open to the public, and those who want to join in simply have to add the appropriate hashtag (such as #mountainmonday) to their post and share it to their Public circle (**Figure 6.31**). The use of hashtags allows other people joining in on the themed day to use the Google+ search bar to see what other Google+ users have shared for the theme. Not only does it help to promote interaction, but it also allows you to show your photography work in a noncompetitive way.

Eric Leslie - Oct 3, 2011 - Public
Mountain Monday curated by +Michael Russell

Mount Shasta is the closest 14er to my home and it's in the backyard of the country my wife grew up in. This is the barn at Grandma's ranch. This was taken last year on Christmas eve. This photo has a lot of sentimental value for me.

Landscapes (85 photos)

Horse Barn in Grenada, CA. From EricLeslie.com ©2010

More photos from Eric Leslie

+1 - Comment - Hang out - Share

+123 - Mara Rose, Brett Halverson, David Bowden, Sandra Parlow...
8 shares - Arsalan Dehghani, Brooke Purdon, Debi Fitzsimmons, L...

24 comments - Eric Leslie, Wasim M., Athena Carey, Brad Gold... ⌄

Figure 6.31 Eric Leslie is one of many organizers for some of the Google+ themed days. He submitted this photo for Mountain Monday, which was originally started by Michael Russell. By joining this themed day, Eric was able to get 123 +1's, 8 shares, and 24 comments.

Colby's Quick Tips

The Google+ daily photo themes are 100 percent open to the public. And you don't need to go through a theme organizer to start your own. Eric Leslie is just one of many organizers working hard to keep theme days organized and running smoothly.

Although anyone can create a theme and put the effort into getting it to catch on, a few Google+ members have gone the extra mile and have begun to organize various lists of themed days throughout the week. One of those organizers is Eric Leslie from northern California. This is what Eric had to say about daily photo themes:

> The daily photography themes on Google+ are a simple way to connect with other like-minded photographers. Each theme is assigned to a day of the week, and anyone can contribute by posting an appropriate photo using the theme's unique hashtag. Then you search for the hashtag, and your stream becomes filled with hundreds of photos matching that subject. You can click Save this Search to create a link in the left column to easily follow the theme later. Each theme has one or more curators who help answer questions and run weekly challenges, and many share the best submissions from the day.

> The themes were born out of the explosive passion in the photography community here on Google+. Everyone has something unique to bring to the table, and there are themes that cover every interest imaginable. Your work gets exposed to a much larger audience that goes beyond the people who have circled you. You can also break into new themes where you are weak and get feedback from the best in the community. This really challenges you to get out of your comfort zone and recharge your creative batteries.

> We create images to get seen, so come join in to get inspired and get noticed.

Table 6.1 provides a handful, but not all, of the Google+ daily photo themes.

Table 6.1 Google+ Daily Photo Themes

Photo Themes	Hashtag
Selfless Sunday	#selflesssunday
Mountain Monday	#mountainmonday
Tree Tuesday	#treetuesday
Waterfall Wednesday	#waterfallwednesday
Travel Thursday	#travelthursday
Floral Friday	#floralfriday
Sunset Saturday	#sunsetsaturday

You can find more daily photo themes by visiting the Daily Photography Themes Google+ page. Use the Google+ search bar to point you in the right direction.

Submit Your Photos to Plus Photo Extract

As Google+ continues to grow, and the photography community on the network continues to establish itself as *the* place for photographers to be on the Internet, you'll start to see more and more curators join in. A curator is not necessarily a professional photographer, but instead is a lover of art who likes to highlight the work of others. One of my favorite curators on Google+ is Jarek Klimek who runs Plus Extract, which is part of his website PhotoExtract.com (www.photoextract.com/plus-extract).

With Plus Extract, Jarek showcases daily sets of some of the top Google+ photographs that were chosen by an algorithm that combines automatic and manual curating (**Figure 6.32**). By doing this, his selections are not based solely on the popularity of a given Google+ photographer, but instead allow photographers with a small following a chance to be featured.

Although Jarek's algorithm automatically finds photographs to include in his daily selections, you can add the #PlusPhotoExtract hashtag to any post containing a photo you would like him to consider.

Figure 6.32 Jarek Klimek's Plus Extract displays images in a beautiful 1150 pixel wide format, allowing chosen images to pop and stand out on the website. The featured photographers receive the credit, and plenty of links are provided directly back to the photographers' Google+ Profile pages.

Patrick Di Fruscia:
A Photographer's Perspective

Patrick Di Fruscia is an award-winning visionary, fine art, nature, and landscape photographer. His work has been published and displayed through a multitude of media (books, calendars, magazines, travel guides, etc.) and by many prestigious companies, such as National Geographic, Greenpeace, and Kodak, just to name a few. His work has also been displayed in several art galleries around the world.

Website: *www.DiFrusciaphotography.com*

Google +: *https://plus.google.com/ 109330684746468207713*

Q Why do you feel photographers have taken to Google+ so quickly?

I personally think there are various factors. First of all, photographers were tired of the way Facebook displayed their pictures. Both the compression and size were unsatisfactory for the demanding photographer. Second, some influential photographers joined Google + right from the start and began spreading the merits of this great social media platform. They quickly convinced their followers to do the same, and in no time this created a so-called snowball effect. The fact that this platform is still new and everyone got on board at the same time created this great community spirit between us all.

Q How many photos do you upload a day? Why?

When possible, I try to upload two to three a day—one first thing in the morning, one in the afternoon, and one in the evening. I never share the same image twice in a day, so if some people saw my previous post, they are likely to appreciate seeing another one of my images. If you want to post the same image again, wait a few days or weeks and share it but at a different time. For example, you may be very proud of a photo you just took. So you decide to share it to the Public circle first thing in the morning. Many will not have the chance to see it due to various factors: time of day, time zone, speed at which the stream is flowing, and so on. It is advisable to share it another day at another time, perhaps in the evening this time. Chances are you will reach a brand-new audience.

Q Do you share your photography work to the Public circle or privately? Why?

I always share my images to the Public circle. Being a professional photographer, exposure and recognition for my art is a must. Most of my clients are not photographers, so if I was to share my art with only my Photographer circle, I would immediately eliminate the chances of exposing my work to some potential clients. One of the main reasons there are so many starving artists out there is not the lack of talent. It's simply because they are unknown. It all boils down to do what you are passionate about, do it well, and then do what you have to do to get recognized in your field.

Q What would your best piece of advice be for those who want to begin uploading and sharing their images?

I would say share your work or opinion two to three times a day at least. Be proactive; respond to all the questions and engage with others. This is called a "social" media, so be social. When you like an image from another photographer, put your pride aside and share your thoughts with that artist. Even share that artist's work if that person really inspires you. You will quickly build strong bonds with other people, and they will be more than happy to pay it forward when they feel the same.

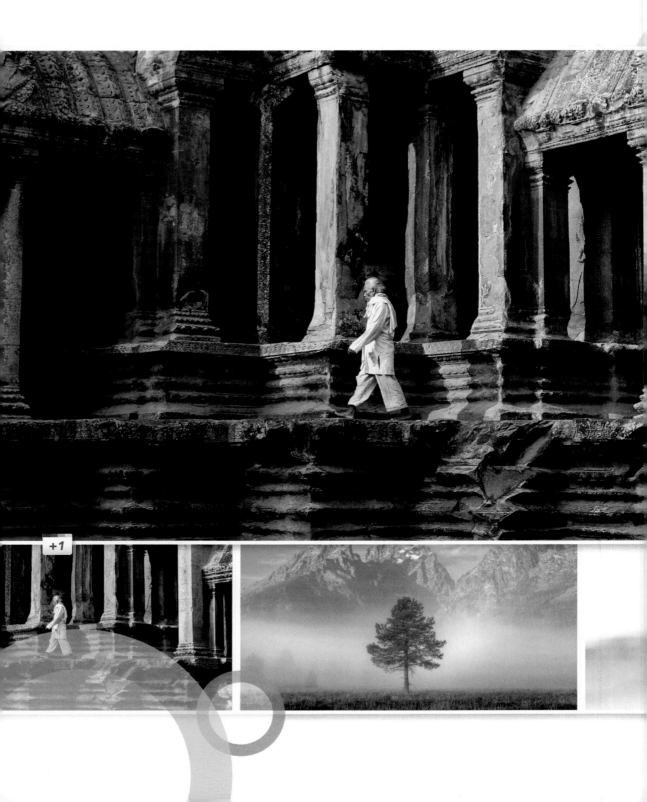

Photo Management on Google+

For many of us, photography is not only a passion, but also an addiction. We can't help the desire to document life by capturing frozen moments in time in various locations and covering many different subjects. For most photographers, the more you shoot, the more you understand the importance of organizing your images. Many photographers have tens of thousands of images stored on their home and office computers, and without implementing essential photo management practices they would have a hard time finding their work at any given time. Managing images on online networks works in a similar way except for one big difference, you are not the only one looking at your work. Organizing your photographs on Google+ not only looks professional, but it allows other Google+ users easy access to view your work based on their interests.

At the heart of Google+'s photo and album management is Google's Picasa Web photo-sharing service. Although many of Picasa's features are being ported directly to Google+, a handful of features have not made the jump just yet, forcing you to make adjustments in Picasa to see the required results in Google+.

In this chapter I'll walk you through the process of organizing your individual photos by showing you how to move images between different photo albums, how to add and edit image descriptions, and how to use the Google+ Creative Kit to help fix minor errors in the images you upload. I'll also show you how to manage your photo albums on Google+ so that you can choose which albums are featured on your profile, how to edit the names of your photo albums, as well as how to select the image you want to represent your various albums.

Photo Organization and Maintenance

Now that you've created your Google+ profile, added several users to your circles, and begun uploading your photography work to share with the world, you need to make sure that your photos are organized, that they display the correct information, and that they are flawless when it comes to how you want to present them.

Editing Image Descriptions

When you first upload an image to Google+, you have the ability to add a description to the photo. Image descriptions are important because they always stay with the image, and they give people a tidbit of background information about the image. If Google+ users are viewing your photography work from the photo section of your profile or from within the Google+ lightbox (**Figure 7.1**), they will not see any of the text that you originally included in the post you published and shared with your followers (**Figure 7.2**).

As you upload more and more images, you might need to update your image descriptions so they are more accurate or so they contain more information for your followers.

Figure 7.1 When viewing an image from within the Google+ lightbox, you and your users can only view the image description, tags, +1's, and comments the image has received.

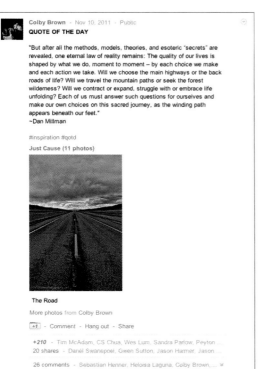

Figure 7.2 The quote I included in the post that contained the image shown in Figure 7.1 is not visible when viewing the image in the Google+ lightbox.

Colby's Quick Tips

Currently, Google+ does not index image descriptions for search. However, if you post an album of photos and someone comments on or +1's one of the photos in the Google+ lightbox, the system will automatically create a single photo post and use the image description as the post text, which then becomes searchable.

To update your image descriptions, follow these steps.

1. Select the image in question and open it in the Google+ lightbox (**Figure 7.3**).

2. Located at the top of the sidebar on the right, you'll notice some text just under your profile thumbnail. Move your mouse over the text until an Edit link appears (**Figure 7.4**), and then click the Edit link.

3. Fill in your image description and finish by clicking the "Add description" button (**Figure 7.5**).

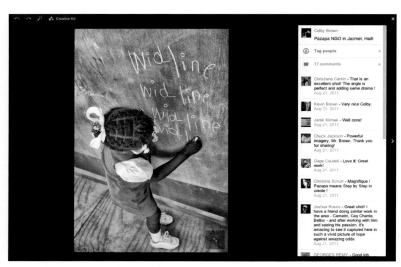

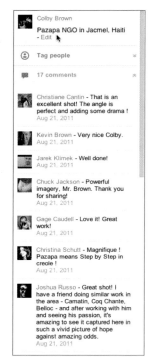

Figure 7.3 To bring an image into the Google+ lightbox, you can click the image in question in a published post, in the Google+ photo section through the Photos tab, or in any Google+ profile.

Figure 7.4 At the top of the sidebar that contains all of the comments your image has received, you'll find your profile thumbnail and the area for the image description just below it.

Figure 7.5 Add or change your image description, and then click the green button when you're done.

Moving Photos from One Album to Another

As previously mentioned, the underlying system for all Google+ images and videos is Google's Picasa photo-sharing service. Although the photo team at Google+ is working hard to implement all of Picasa's management features into Google+, the team has not yet been able to do so for every feature or setting. The ability to move images from one album to another is one of the missing features in Google+.

To move a photo from one of your Google+ photo albums to another, follow these steps.

1. Access Picasa Web Albums by visiting http://picasaweb.google.com. Sign in to your Google account if necessary.

2. Click the photo album that contains the image you want to move (**Figure 7.6**). If you don't see the album in question, click Show More Albums.

3. Click the Organize tab at the top of the photo album window (**Figure 7.7**).

4. Select the photo(s) you want to move to a new album. A blue frame will appear around the highlighted images. Click the Move button when you've made your selections (**Figure 7.8**).

Figure 7.6 The home page for Picasa Web Albums displays thumbnail previews of all the albums you have uploaded to Google+.

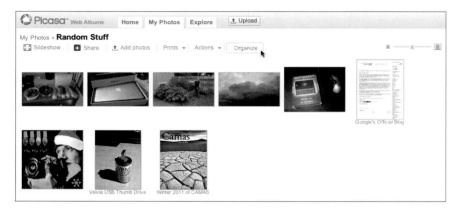

Figure 7.7 Once inside a photo album in Picasa Web Albums, you can see and interact with all of the images in that album. Many of the features used to manage and organize photos will eventually be available in Google+.

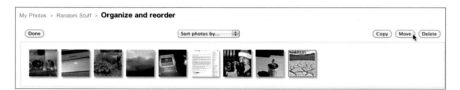

Figure 7.8 After clicking the Organize tab, thumbnail previews of all the images in the selected album will be displayed. Select the photo(s) you want to move, and then click the Move button.

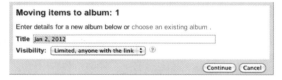

Figure 7.9 The window that opens after you have selected the photo(s) you want to move allows you to create a brand new album if an existing album doesn't work for you.

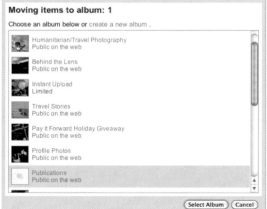

Figure 7.10 If you don't see the photo album that you want to move the selected photo(s) to at first, scroll down the window.

5. You can choose to create a new photo album by typing in the Title box, or move the photo(s) to an existing album by clicking "choose an existing album" (**Figure 7.9**).

6. If you decide to move to an existing album, click "choose an existing album," select the destination album for the selected image (**Figure 7.10**), and then click the Select Album button.

Editing Photos with the Google+ Creative Kit

One of the most helpful and entertaining tools on Google+ is the Creative Kit, which is available to every Google+ user. With it you have the ability to do nonadvanced yet very creative edits to any image you have uploaded to the network. As photographers, we often want to put our best foot forward when displaying our work; however, sometimes we can miss a small detail. Whether you want to touch up a photo you took on your mobile phone, spice up your Google+ profile photo, or clean up an image you uploaded in a hurry, the Google+ Creative Kit is the tool for you.

To access the kit, follow these steps.

1. Click one of your photos to display it in the Google+ lightbox.

2. Click the Creative Kit button in the top-left corner of the lightbox (**Figure 7.11**).

With the Creative Kit you have the ability to do basic edits, such as crop, rotate, tweak exposure, adjust colors, sharpen, and resize, as well as add more stylized effects, such as converting an image to black and white (**Figure 7.12**).

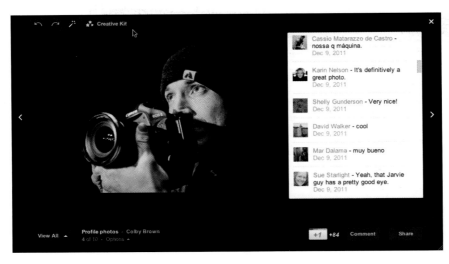

Figure 7.11 You can only use the Google+ Creative Kit on the images you upload to the network.

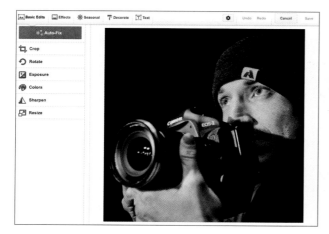

Figure 7.12 With the Creative Kit you can make all sorts of adjustments to your image. Although the program is not as powerful as a professional editing application, it is great to use if you notice a minor error on one of your images and you don't want to upload a new image.

Figure 7.13 This is my 2011 holiday profile photo. Not only do many photographers edit their profile images during the various holidays throughout the year, but many of the big executives at Google do as well. It is purely for fun.

The Creative Kit offers five main tabs:

- **Basic Edits.** Allows you to make very simple adjustments to an image, such as cropping or fixing the exposure.

- **Effects.** Allows you to convert your image to black and white, make it look like a Polaroid, and add other funky color effects.

- **Seasonal.** Allows you to add seasonal effects, such as Christmas lights at the end of the year or spider webs at Halloween.

- **Decorate.** Allows you to add fake mustaches, add face paint, or simply doodle on your photo.

- **Text.** Allows you to add all sorts of text to your image.

During the holidays, many Google+ users will edit their profile image using the Seasonal tab in the Creative Kit to have a little fun. The holiday version of my Google+ profile image is shown in **Figure 7.13**.

When you are finished editing your photo, click the Save button in the top-right corner of the Creative Kit. You'll then be asked if you want to replace your photo or save a new copy.

Photo Album Organization

Although cleaning up individual images and providing accurate image descriptions are important, very often your followers' first experience with your work will be through your photo albums. Making sure your albums have accurate titles, are displayed in the correct order, and emphasize the right cover image all play a large role in how your followers experience your photography work and portfolio.

Renaming Photo Albums

After uploading a couple of hundred photographs to Google+, you might want to consolidate some of your photo albums to create a more effective presentation of your photography portfolio. Instead of starting from scratch with a brand new album, you can easily change the name of your albums within Google+.

To rename a photo album in Google+, follow these steps.

1. Click the Photos icon on the Google+ navigation bar (**Figure 7.14**) to go to your Google+ photo section.

2. Click the "Your albums" link in the left sidebar (**Figure 7.15**).

Figure 7.14 The Photos icon is located in the Google+ navigation bar and is represented by an image of a green mountain with a blue frame around it.

Figure 7.15 The "Your albums" section on Google+ displays beautiful thumbnail images that represent the various albums you have created on Google+.

3. Click the album you want to rename.

4. Move your mouse over the current name of the photo album, which is located near the top of the page. A blue frame appears around the album name. Click anywhere inside that frame to edit the name of your album (**Figure 7.16**).

5. When you are finished, just click anywhere outside the frame or press Enter to save the changes (**Figure 7.17**).

Figure 7.16 There is no edit button; all you need to do to rename your photo album is to click the album title, change the name, and press Enter.

Figure 7.17 Changes to a photo album title are instant. You can see the results as soon as you press Enter or click away from the photo album title.

Colby's Quick Tips

Use descriptive titles when naming your albums. If you want to create an album for black-and-white landscape photography, label it accordingly so that visitors to your albums will get an idea of what to expect in each album.

Selecting the Photo Album Image Cover

Photographers are very visual creatures and have a thing for aesthetics. So, it is essential that all of your photo albums have the image you want representing each album. Although not every image you take is award winning, you should put your best foot forward when displaying your art.

As vital as choosing which photos represent your various albums is, this feature is not currently available in Google+, so you must venture to Google's Picasa Web Albums to adjust the photo album cover.

To change a photo album image cover, follow these steps.

1. Access Picasa Web Albums by visiting http://picasaweb.google.com. Sign in to your Google account if necessary.
2. Click the photo album in question (**Figure 7.18**).

Figure 7.18 The home page for Google's Picasa Web Albums displays thumbnail previews of your various photo albums. Click the photo album you want to modify.

Colby's Quick Tips

I recommend that you select an eye-catching image for your photo album cover. It doesn't have to be the best image in your album, but it should be one that looks good in the thumbnail box and represents the rest of the images in the album.

Colby's Quick Tips

While you are in Picasa Web Albums, you can track the number of views your photographs have received on Google+. Click the album containing the specified image, and then click the image. Located just below the image is a gray bar that shows "Views 10,500," for example.

3. Click the photo you want to represent the photo album as its cover (**Figure 7.19**).

4. Click the Actions menu above the selected image and choose "Set as album cover" (**Figure 7.20**).

There is no confirmation that the change took effect, but if you return to Google+, you'll see the new album cover displayed on the selected photo album (**Figure 7.21**).

Figure 7.19 Within a photo album, you'll find thumbnails that represent previews of all the images inside the selected photo album. Click the image you want to be on the photo album cover.

Figure 7.20 The Actions menu just above the image allows you to set the current image as the album cover; delete the image; and edit, copy, move, and download the selected image.

Figure 7.21 Although you don't receive a confirmation that you changed a photo album cover, a quick visit back to Google+ will reflect the changes instantly.

Figure 7.22 Your Google+ profile gives you the opportunity to display four albums on the main page of your Photos tab. Choosing which albums are featured here gives you more control over directing viewers of your profile to the images and albums you want them to see.

Reordering Your Profile Photo Album Display

When you're looking at the photo section in your Google+ profile, you'll notice that only four of your photo albums are visible (**Figure 7.22**), even though you probably have many others (all of which you can access by clicking "View all of your albums"). The albums that appear on this page are displayed in the order in which the albums were created. To customize the albums you want to display on your profile, you need to edit the album properties in Picasa Web Albums.

By default, the first two albums displayed on your Google+ profile are "Profile photos" and "Photos from posts," leaving you only two open spots to showcase your work. The "Profile photos" album must be displayed

on your profile, but you can remove the "Photos from posts" album from appearing by moving all of the images in that album to other albums using the method mentioned in the "Moving Photos from One Album to Another" section earlier in this chapter.

To change the order of the photo albums that are displayed on your Google+ profile, follow these steps.

1. Access Picasa Web Albums by visiting http://picasaweb.google.com. Sign in to your Google account if necessary.

2. Click the photo album you want to appear first (**Figure 7.23**).

3. Click the Actions tab menu and choose "Album properties" (**Figure 7.24**).

Figure 7.23 The home page of Picasa Web Albums displays many of your Google+ photo albums. If you do not see the album you are looking for, click the Show More Albums link.

Figure 7.24 Just above the images thumbnails in the selected photo album, you'll find a series of tabs and settings. Click the Actions tab, and then choose "Album properties" from the menu.

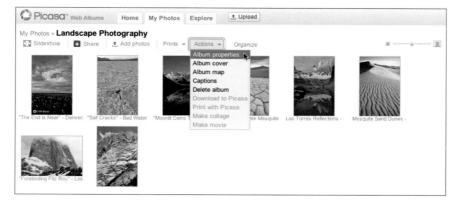

4. Click the Date section to bring up a calendar and select a date in the future, such as July 17, 2015 (**Figure 7.25**). When you are finished, click the Save Changes button.

This photo album will then appear second in line (next to the "Profile photos" album). To adjust the order of the rest of your albums, all you need to do is repeat the preceding steps, but each time select a date earlier than one you just selected. So instead of July 17, 2015, select July 10, 2015 for the album that you want to appear next. Continue this practice until your photo albums are in the order you desire.

Colby's Quick Tips

Note that anytime you add another photo to your "Photos from posts" album, that album will reappear on your profile, knocking out one of your selected photo albums from being displayed first. If you move all photos from the "Photos from posts" album to other albums, it will disappear from your profile altogether.

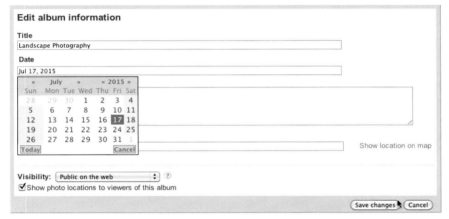

Figure 7.25 By choosing a date in the future for creating a photo album, you are in essence tricking the Picasa system into displaying the album on the main section of your Google+ profile Photos tab section.

Alex Koloskov:
A Photographer's Perspective

I am a mix of technicality, innovation, and out of the box thinking; I don't know the rules, nor do I care about them. I am inspired by progress and movement. I am incredibly persistent and never take "less than perfect" for an answer.

It allows me to experiment, see outside the borders, challenge the authorities, and create a stunning photography style that is crisp, sharp, and crystal clear.

Website: *www.koloskov.com*

Google+: *https://plus.google.com/102865263115020893218/*

Q Your photography albums on Google+ are very organized. Why did you take the time to set up your Google+ galleries this way?

Because my photography interests spread over a relatively wide area, from landscapes to studio and liquid photography, the only way to organize images is to keep them in separate albums. Also, having dedicated albums helps when I need to share the whole album as an illustration to my Google+ post.

Q Do you showcase your best photography work on Google+? Why?

It is very important to showcase only the best of your images, IMO. Although I post many that are not the best but instead are funny or interesting, I do not include them in my Google+ albums. Such images will sink in a stream, whereas albums will stay clean and well organized. I treat them as my Google+ portfolio, meaning I can have only the best images in my albums.

Q Why are captions important?

There are three main reasons why they are important to me:

First, I use them to tell a viewer about the photo: The caption can be some technical details or the information about where I shot it. Such description promotes dialogue with the viewer and makes browsing through my albums more interesting.

Second, I use them to include credits for the creator(s): Beside a photographer's name, I always include the name(s) of those who worked on the

image, such as the postproduction artist (if the image was manipulated after the shot).

Third, I always include a website that I want to promote and expose with the image—not only for the promotion, but such a link always leads to something potentially interesting to a viewer: an educational blog, and so on.

Q What would your best piece of advice be for those who want to manage their photographs on Google+?

- Use Picasa Web Albums (picasaweb.google. com) to keep your Google+ albums organized. You can set or change an album cover image, rearrange images within an album, create new albums and copy or move your photos between them, and perform many other useful Google+ photographer tasks. For example,

from time to time I change the first (not cover) image in the album I want to share on my Google+ stream: The first image is what is displayed in the large thumbnail on a Google+ post, and it is best to have a new image every time I share the whole album.

- If you have different areas of interests in photography, keep images from these areas in separate albums. However, if you concentrate in only one area, it's wise to have only one album containing the most important and interesting images for your area. I agree with Trey Ratcliff, who prefers to keep everything in one album. Once viewers start browsing your images, they're less likely to switch albums.

- Upload relatively large images: my favorite size is 1200 x 800 px. It looks the best on medium- and large-size monitors.

Using Hangouts to Interact with People Worldwide

There is no doubt that Google+ Hangouts is the single most talked about and exciting Google+ feature. Companies like Skype and Fring have had their foot firmly planted in the one-on-one video chat business for some time, but Google+ Hangouts gives you the ability to easily and seamlessly jump into a group video and converse with nine other Google+ users (ten in all) from anywhere in the world—for free. Imagine having the opportunity to talk face to face with your clients or customers, watch another photographer teach a new digital-editing technique, or strike up a conversation with a professional photographer you have admired for some time. With the added capability of screen sharing, document collaboration, and recorded video streaming straight to YouTube via Hangouts On Air, the Hangouts feature will change not only the way you interact with your followers, but the very way businesses of all sizes will approach marketing.

In this chapter I'll walk you through Google+ Hangouts, talk about the various kinds of hangouts, show you how to join or create your own hangouts, and discuss in depth how hangouts have the potential to change the way companies think about marketing their products or services.

The Importance of Google+ Hangouts

In Chapter 2 I talked about the importance of consistency in the messages and images you publish, and of personal interaction as well. As digital technology continues to become more ingrained in our everyday lives, the value of interacting with individuals on a more personal level will only increase, especially for those running businesses. With Google+ you have the ability to interact with millions of other individuals across the globe who share in your passions and interests. Using hangouts, you can bring live interaction back to social networking (**Figure 8.1**).

Figure 8.1
Google+ Hangouts gives you the ability to talk, share, and collaborate with various individuals worldwide. You can jump into a hangout to talk with potential clients, collaborate on a project with some of your fellow employees, or just share your experiences with other Google+ users.

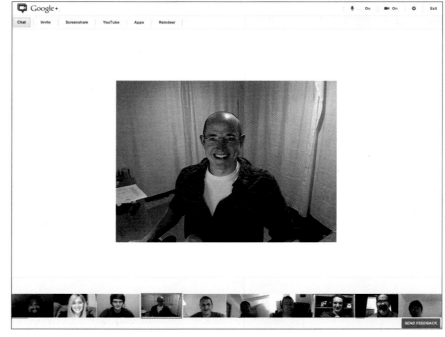

Figure 8.2 Trey Ratcliff is known for his HDR photography work and popular website, Stuck in Customs. Like many well-established professional photographers on Google+, he regularly holds hangouts to share his experiences and knowledge, as well get to know those who follow his work.

As a professional photographer, you have the ability to develop relationships with your potential clients and customers through Google+ Hangouts by hosting webinars, discussions, and question and answer sessions. As an aspiring photographer, you can jump into a hangout with some of the top photographers in the world and ask them questions, watch them teach their craft, and get to know what makes them unique (**Figure 8.2**). Google+ Hangouts is starting to change social marketing, and many creative types are already putting the feature to good use.

Using Hangouts to Change Social Marketing

Google+ Hangouts on its own is not a new concept (video conferencing has been a possibility for years), but Hangouts On Air will certainly change the way businesses approach marketing to the masses. Having the ability to live stream and automatically record a Google+ hangout, in essence, allows you to have your own TV station that you can broadcast to the world. There is no need for an expensive computer system or terabytes of storage to host your video recordings; everything is automated, the process is simple, and everything is free.

In the past a company would spend hundreds or thousands of dollars for an ad campaign in a magazine or a TV commercial to reach new users. The problem with those avenues for marketing a product is twofold: cost and a lack of interaction. With Google+ Hangouts I've already seen Michael Dell of Dell computers host question and answer sessions with customers (**Figure 8.3**), the owners of SmugMug host and sponsor several photography related hangouts, and even musicians like Daria Musk host live concerts (**Figure 8.4**), all from within Google+.

So why should this matter to you? As a consumer, you will soon have the ability to have a more personal and connected relationship with the companies and products you enjoy. As a photographer, the avenues in which

you will want to spend your time marketing your business not only will drastically change, but will allow you to get to know your clients and followers of your work like never before. You will be able to break free from the limitations of digital marketing and get back to the heart and soul of building your business through personal interaction.

Figure 8.3 Michael Dell, the CEO of Dell computers, is known to hold Google+ hangouts to get feedback and talk to customers who purchase his products. Nowhere else on the Internet is this level of access possible.

Figure 8.4 Daria Musk is an incredibly talented singer and songwriter who has taken full advantage of Google+ Hangouts. Her live streaming of a concert on New Year's Eve reached hundreds of thousands of people who might not have heard of her otherwise.

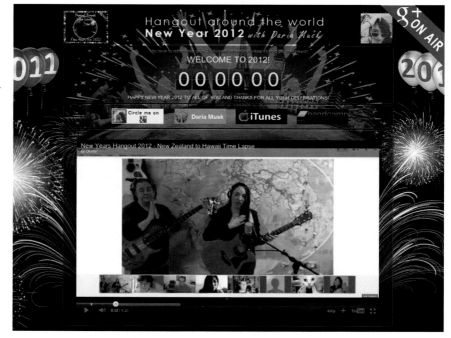

Creative Uses of Hangouts

With over 100 million Google+ users, there is no doubt that many individuals have gotten creative when it comes to utilizing the Hangouts feature to suit their needs and interests. The following two lists provide of a handful of creative hangout uses for photographers and nonphotographers alike.

Photography-specific uses include:

- Photography talk shows (webisodes)
- Photo critique group sessions
- Photography gear reviews
- Digital editing workshops (with screen sharing)
- Photo club meetings
- Pre-trip photography workshop discussions
- Hangout via Google+ mobile application during a photography shoot
- Photography trip planning

Nonphotography-specific uses include:

- Customer service for large companies
- Cooking classes
- Yoga hangouts
- Live music concerts
- Cable news hangouts live on air
- Talent shows
- Improv comedy shows
- Movie nights (via the YouTube feature)
- Talks with the Dalai Lama
- NASA question and answer sessions

Needless to say, the opportunities and potential to not only interact with other Google+ users, but find unique and creative ways to build your photography business or increase your skills are endless.

Figure 8.5 This screen shot was pulled from the Google+ home page, which advertises the various prominent features of the network. This image for hangouts has not changed since day one.

 Hangouts

Types of Google+ Hangouts

When Google+ launched its service at the end of June 2011, only one form of hangouts was available (**Figure 8.5**). As with many aspects of the network, Google employees have worked nonstop to continue to add new features, fix bugs, and listen to customer feedback to improve the user experience on Google+.

Less than three months after the launch, Google added Hangouts with Extras—a new and improved Google+ Hangouts option. Hangouts with Extras offers a few new features that allow you to interact and engage with other users in a new way. Instead of replacing the original, incredibly popular Hangouts feature, Google provides you with the choice of creating a hangout you feel works for you.

Original Google+ Hangouts

As mentioned earlier, Google+ Hangouts has been around since the network launched. However, many of the features discussed in this chapter are currently being tested by a handful of users, including me. If your screens do not match my screen shots, don't worry; Google is working hard to roll out these features in the near future.

Colby's Quick Tips

To bypass the automatic switching of users who are speaking and have center stage in a hangout, you can simply click the thumbnail of the user you want to view. A blue frame will surround that person's thumbnail, even if that person is not speaking.

Google+ Hangouts layout

In the middle of a hangout screen you'll find the individual who has center stage (**Figure 8.6**). Google has implemented advanced computer algorithms that detect who is talking and should have your attention. Throughout a given hangout, if left on the default setting, the highlighted individual will change depending on who "has the floor" at any given moment.

At the bottom of the Hangout window you'll find live thumbnail video feeds of everyone currently in the hangout (**Figure 8.7**). The thumbnail of the individual who currently has the floor will have a blue frame. At the bottom right of the screen is a Send Feedback button that allows you to tell the Google+ Hangouts team about any bugs, your thoughts, and any feature requests you might have.

Colby's Quick Tips

On occasion you might be forced to block or mute another Google+ user in a hangout. To do this, simply move your mouse over that person's thumbnail image and click the Mute or Block icons that appear.

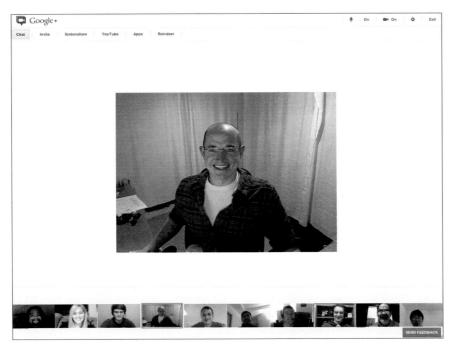

Figure 8.6 The original and still wildly popular Google+ Hangouts feature has received a few updates and upgrades since the network launched, allowing it to run faster and smoother while adding in desired features like screen sharing.

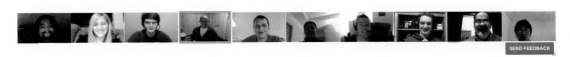

Figure 8.7 The video thumbnail feeds allow you to keep an eye on the other Google+ users in the hangout while still focusing your attention on the user who currently has center stage.

Google+ Hangouts tabs

The Hangouts tabs allow you to enable various features in Google+ Hangouts (**Figure 8.8**):

- **Chat.** If you choose this option, a side chat box appears on the left side of the Google+ window, allowing you to text chat with other Google+ users in the hangout.

- **Invite.** You can invite other Google+ users to the hangout or send an invite to an entire circle, including your Public circle, which makes the invitation visible to everyone on Google+ (**Figure 8.9**).

- **Screenshare.** You can share your screen with other Google+ users in the current hangout (**Figure 8.10**). Click the tab and then select the window on your computer that you want to share.

- **YouTube.** You can watch a YouTube video with the other users in the hangout, creating a virtual movie theater on the Internet.

Figure 8.8 In the top left of your Hangout window you can access some of the main features, such as screen sharing and watching YouTube videos with other users in the hangout.

Figure 8.9 Even after you've entered or started a Google+ hangout, you have the ability to invite other Google+ members or entire circles.

Figure 8.10 The ability to share your screen in a Google+ hangout can lead to endless possibilities when it comes to interacting with clients, educating other photographers, or collaborating on projects.

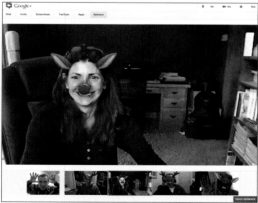

Figure 8.11 In a similar fashion to the Google+ Creative Kit mentioned in Chapter 7, the seasonal effects are a fun tool that allow you to get creative and have a good time with other Google+ users.

- **Apps.** You can enable various third-party applications that allow you to change or alter your experience in Google+.

- **Seasonal graphics.** You can add fun and entertaining graphics to your video feed that change with the seasons. **Figure 8.11** shows Google+ users adding reindeer antlers and Rudolph's nose to their video feeds.

Google+ Hangouts settings

In the top right of your screen you'll find a few Google+ settings that allow you to control part of your user experience in a hangout (**Figure 8.12**):

- **Mute Audio.** Mutes or turns off your audio feed so that other users in the hangout cannot hear you.

- **Mute Video.** Turns off your webcam feed so that other users can't see you. It turns your thumbnail black.

- **Google+ Hangout Settings.** Gives you access to change which microphone, web camera, and speakers you want to use for your hangout, as well as to adjust your connection speed to account for slower Internet connections (**Figure 8.13**).

- **Exit the Hangout.** Closes the Hangout window and ends the current hangout session.

Figure 8.12 You have quick access to a few key features, such as muting your audio or video from within the Google+ window.

Figure 8.13 Not only do you have the ability to change the microphone or web camera in the Google+ Settings, but you can test the changes as well through a video feed of your webcam and an audio bar that lets you know how loud you are when you speak.

Trey Ratcliff:
A Photographer's Perspective

Trey Ratcliff is the old-school gentleman explorer with really cool toys behind StuckInCustoms.com. He's a travel photographer who shares new photos every day on his blog, and he takes the time to talk about the art and science behind his work. Trey feels that photography is a lifestyle first and a career second.

Website: *www.stuckincustoms.com*

Google+: *https://plus.google.com/105237212888595777019*

Q Hangouts seems to be one of the most talked about Google+ features. Why is that?

Photographers are lonely people. Our sport is a solitary one. We take photos by ourselves. We post-process by ourselves. But, just like normal humans, photographers like social interaction too. Because we're in front of our computers so much, the chance to hang out with other photographers face to face is inviting.

It reminds me of the late nineteenth century in France when the great impressionists would gather at local cafes in Paris and talk about their art. It's also one of the reasons there was such an explosion of creativity during that time period.

Q How do you use Google+ Hangouts?

I use the Hangouts feature to discuss photography with old friends and new friends. In my hangouts I prefer to have a mix of veteran photographers and new photographers. Since Google+ has come along, a ton of people have become my followers. It seems like a good opportunity to expose new photographers to hundreds of thousands of other people, especially with the ability to broadcast live on YouTube.

Q What are a few creative examples of Google+ Hangouts that you have seen?

I love to hear photographers share their work and talk openly about it. There is a stream of consciousness that comes out if people are truly

open. I like using hangouts to present people with chances for these little magical events to transpire.

Q For new photographers interested in getting involved with Google+, what is the best piece of advice you would give them about hangouts?

When you go into a room, don't assume that all the people there are friends and you are an outsider. That is rarely the case, even if they seem to have a nice rapport with the other people in the hangout. Just be normal and engaging. Don't let fear demotivate you. Let the possibilities of *what can be* motivate you to engage.

Hangouts with Extras

The newest version of Google+ Hangouts is Hangouts with Extras. It contains many features not found in the original version as well as a noticeably different layout.

Hangouts with Extras layout

One of the first differences you'll notice in Hangouts with Extras is that the video thumbnails of the various Google+ users in the hangout are now located along the right side of the screen (**Figure 8.14**). Just as before, you have the ability to mute or block an individual if you hover your mouse over that person's thumbnail and select the respective option. On the left side of the screen is the Group Chat feature, which is identical to the one in the original Google+ Hangouts.

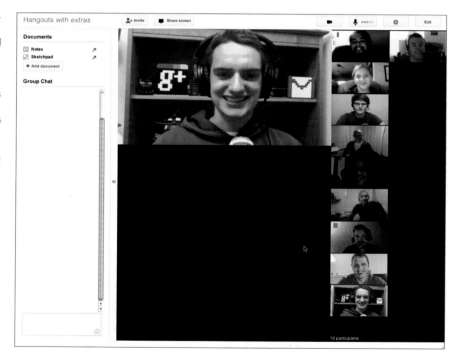

Figure 8.14 Hangouts with Extras gives you a handful of extra tools that you do not have in the original Google+ Hangouts to connect and engage with others Google+ users. You can share documents, editing them together in real time, and you can call phone numbers to invite other people (who are not Google+ members) into the conversation.

Hangouts with Extras features

The Hangouts with Extras features are what truly separate it from the original Google+ Hangouts. With these features you can take notes, draw, share Google Docs documents, share your screen, and even make phone calls to anyone in the world:

- **Notes.** Located above the Chat window, the notes feature opens a new Google Docs document that allows you to take notes throughout the hangout (**Figure 8.15**). Other users in the hangout will not see your notes until they too click the Notes icon. The notes document will continue to save automatically while it is open, allowing you to retrieve your hangout notes after the hangout has ended by accessing your Google Docs account via http://docs.google.com.

- **Sketchpad.** Located above the Chat window, the sketchpad is very similar to the old paint programs you had on your computer when you were younger. You can create simple graphics, use a paintbrush, and even import images from your Google+ account, all in real time with everyone else in the hangout (**Figure 8.16**).

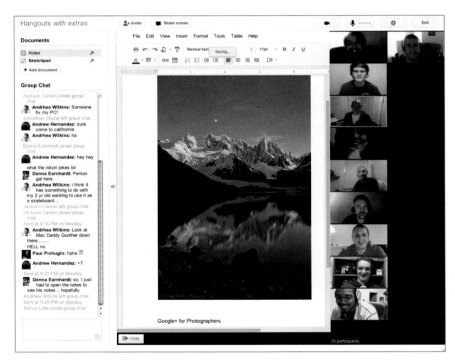

Figure 8.15 The Notes feature on Google+ allows you to write down information that pertains to the Google+ hangout you are in and revisit it at any time.

Figure 8.16 The Sketchpad feature allows you to collaborate and create some unique "art" with your fellow Google+ users in the hangout in real time. This sketch was created by nine users who jumped in my Google hangout so that I could take these screen shots.

Figure 8.17 Google Docs is one of my favorite Google products. It gives me a fully functional document editor, like Microsoft Word, that I can use on any browser and on any computer on the Internet. I can then share documents with others and collaborate in real time.

- **Add a Document.** If you have created a Google Docs document that you want to share with other users in the hangout, you can click this link (located above the chat box) to bring up a list of all the saved documents you have in your Google Docs account (**Figure 8.17**).

- **Screen Sharing.** Located just above the main video feed is the Screen Sharing button. This feature works in the same way as the feature in the original Google+ Hangouts (**Figure 8.18**).

- **Phone Calls from Hangouts.** A unique feature of Hangouts with Extras is the ability to invite someone to a hangout by calling that person from within the Hangout window. Simply click the Invite button at the top of your screen, and then click the Phone option on the left side of the window (**Figure 8.19**). This feature is free when you make phone calls to the United States and Canada but does cost money if you try to call individuals who live elsewhere.

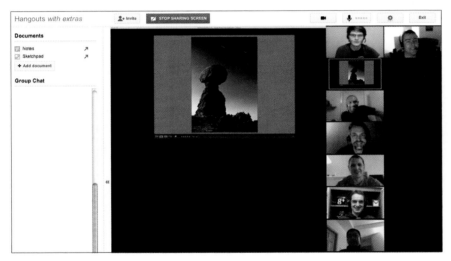

Figure 8.18 In the same fashion as the original Google+ Hangouts, you can share your screen with other members in the hangout, allowing you to show off the latest images you are editing or any other window currently open on your computer.

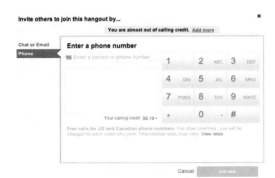

Figure 8.19 Making phone calls from within hangouts is a new feature that allows you to easily connect with more people around the world. Google is working hard to create features that work not only for the average user, but for large corporations as well. Seamless networking with anyone around the globe is not far off.

Hangouts On Air

One of the most exciting features within Google+ Hangouts is the ability to live stream and record hangouts with the entire world. Normally, you are limited to just ten Google+ users in a hangout; however, with Hangouts On Air you have the ability to offer live streaming—anyone on Google+ can watch your hangout live (**Figure 8.20**). In addition, the Hangouts On Air feature also records the hangout to YouTube, so that you can share the recorded video with anyone who did not get a chance to watch it live.

Currently, this feature is limited to only a handful of Google+ users who have been very active in Google+ Hangouts, including me. However, at some point in the first half of 2012, this feature will be rolled out to everyone, allowing you to literally be your own online TV station.

To watch a Hangouts On Air live stream, simply look for the graphic shown in **Figure 8.21** to roll through your Google+ stream. Click the Play arrow in the middle of the image and you are good to go.

Figure 8.20 The Hangouts On Air feature has the potential to completely change the way companies approach marketing. Having the ability to directly reach millions of potential clients in a personal way for free is huge. In the near future, you might not have to spend hundreds if not thousands of dollars on marketing your photography business, but instead will be able to focus on social marketing and reaching your clients on a more personal level.

Figure 8.21 Anytime you see this image in your Google+ stream, you have the ability to watch the live streaming hangout in real time without having to worry about getting one of the ten available spots in the hangout.

Once Google+ has enabled this feature on your Google+ account, follow these steps to start live streaming and recording a Google+ hangout.

1. Click the "Start a hangout" button on the right sidebar of your Google+ stream.

2. Click the "broadcast and record" link located under your video preview (**Figure 8.22**).

3. Enter a description for your hangout, and then click the Hang Out button (**Figure 8.23**).

4. You will be asked to accept the Google+ Hangouts On Air and YouTube terms, which state that you are responsible for the content of the hangout.

After the hangout has ended, the recorded hangout will then be placed on your YouTube account.

Check your hair and make sure your mic works!

Figure 8.22 It's easy to miss the small text under the Hang Out button, so be sure to look for it. If you don't see the "broadcast and record" link, you do not have this feature enabled yet.

Check your hair and make sure your mic works!

Figure 8.23 Don't forget to fill out the description of your hangout, because it tells other Google+ users what your hangout is about and will be part of the recorded hangout that is sent to your YouTube account.

Hangouts with Extras settings

Located in the top-right corner of the Hangouts with Extras window are your settings. These function the same way as those in the original Google+ Hangouts feature:

- **Mute Audio.** Mutes or turns off your audio feed so that other users in the hangout cannot hear you.

- **Mute Video.** Turns off your webcam feed so that other users cannot see you. It turns your thumbnail black.

- **Google+ Hangout Settings.** Gives you access to change which microphone, web camera, and speakers you want to use for your hangout, as well as to adjust your connection speed to account for slower Internet connections.

- **Exit the Hangout.** Closes the Hangout window and ends the current hangout session.

Getting Involved in Google+ Hangouts

When it comes to getting your feet wet with Google+ Hangouts, you have two options: start your own or join someone else's.

Starting Your Own Hangout

To create your own Google+ hangout, follow these steps.

1. On your Google+ stream page, click the "Start a hangout" button on the right sidebar (**Figure 8.24**).

2. On the right side of the window that appears you'll see a listing of hangouts currently in progress from those in your circles (**Figure 8.25**). To join one of these hangouts, just click the Join this Hangout link below each listing.

 To create your own hangout, utilize the box in the center of the window. If you want to start an original hangout, choose the individuals or circles you want to invite, and then click the Hang Out button. If you want to start a Hangouts with Extras hangout, click the text located at the bottom of the windows.

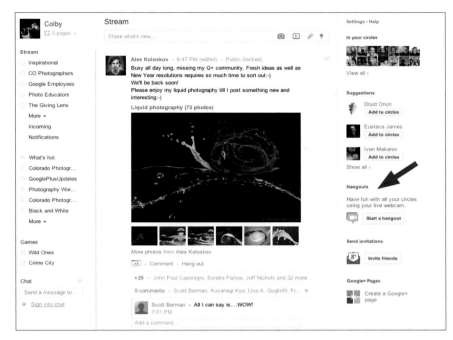

Figure 8.24 To start your own Google+ hangout, click the "Start a hangout" button located on any of your Google+ streams. If you try to start a hangout while looking at one of your circle filters, Google+ will automatically add the circle to the list of people to invite.

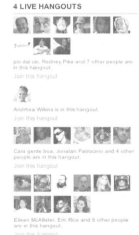

Figure 8.25 Often, you'll want to start a hangout when plenty of other hangouts are currently live. If you are new to Google+ and want to connect with other Google+ users, jumping in an established hangout might be a better option than creating your own. You certainly have the ability to host a private hangout between friends, but filling a public hangout before you've established a following might be difficult.

Figure 8.26 Filling out the description is important not only because it gives your followers an idea of what the hangout is about, but also because the description is actually searchable via the Google+ search bar.

On the Hangouts with Extras start-up screen, you'll be asked to fill out a hangout description as well to let those you have invited know what the hangout is about (**Figure 8.26**).

Joining a Hangout

You can join a Google+ hangout in three ways: through your stream, through the Notification box, and through Google Chat.

Joining a hangout through your stream

When you are flipping through your stream, you might come across a post that looks like **Figure 8.27**. This post indicates an open invitation for you to join the hangout. To join, simply click the "Join this hangout" button at the bottom of the post.

Joining a hangout through your Notification box

When you click your red Notification box on the Google+ navigation bar, you might see a notification that looks like the one in **Figure 8.28**. You need to click that notification to bring up the window (**Figure 8.29**) that allows you to join the hangout.

Figure 8.27 When you come across a Google+ hangout in your stream, but did not receive a notification about the hangout, it means that the Google+ user who created the hangout invited all those in a large circle that you are in. You'll receive a Google+ notification if the host invites you individually or if the host invites a circle with fewer than 100 users.

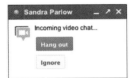

Figure 8.28 When you see this message appear in your Notification box, it means that someone has intentionally invited you to a Google+ hangout.

Figure 8.29 When you are ready to join a hangout, adjust your camera and microphone settings, click the "Join this hangout" button, and get ready to start.

Figure 8.30 When you hear the music playing, click the "Hang out" button to join the hangout. You do not need to be chatting with the individual who invites you in order for the music to begin playing.

Joining a hangout through Google Chat

With Google Chat being fully integrated into Google+, you'll be notified via a chat box if another Google+ user in your circles sends you a direct invite to a hangout. You'll know when this happens because you'll hear a tune on your computer speakers and see an image pop up that looks like the one in **Figure 8.30**.

+1

Google+
on the Go

 Photographers always seem to be on the move. Although not all photographers have the ability to jump on a plane and head to Patagonia to explore its rugged wilderness, many of you take images while away from your homes.

Whether you are simply on a walk around the neighborhood, heading to a meeting with a client, or on the way to a day job, staying connected is often required to keep your followers engaged and your Google+ profile or page from becoming stagnant. One of the best ways to stay connected is through the Google+ mobile app.

In this chapter, I'll cover the ins and outs of the Google+ mobile app and explain the importance of keeping in touch while on the road.

Google+ Mobile App

When you are on a shoot or simply away from your computer, the Google+ mobile application allows you to stay connected and engaged with other Google+ users with ease. It has nearly all of the functionality of the web browser Google+ experience, including the ability to join hangouts, organize your circles, and publish content. As mentioned in Chapter 2, one of the most important aspects of building a brand and a following on online networks is consistency. Maintaining your online presence while traveling is key.

Colby's Quick Tips

The search feature on the Google+ mobile app will find Google+ pages as well when you select the People section. A search for "Android" will bring up the Android Google+ page and all those who have Android in their profile.

The Google+ mobile application is available for Android and iOS (Apple) devices. Because of the high-speed nature in which mobile applications are developed and updated, the Android and iOS applications might have slight discrepancies between them at any given time. Although you can also access Google+ from a mobile web browser, you will be limited in what you can do. **Table 9.1** showcases the various features available through mobile devices.

Table 9.1 Availability of Features in the Google+ Mobile App

Feature	Android App	iPhone App	Web App
Messenger	•	•	
Instant upload	•		
Share in the stream	•	•	•
Reshare posts	•	•	•
Nearby streams	•	•	•
Create circles	•	•	•
Check-ins	•	•	•
Join hangouts	•	•	•
Moderate comments & posts	•	•	•
Post & delete photos	•	•	
Push notifications	•	•	
Posting widget	•		

All screen shots and featured instructions included in this chapter are for a Google Android device, but similar functionality and layout are at the core of the applications for each operating system.

Core Features

Google has put in a lot of energy and effort to bring several features and advanced functionality to the Google+ mobile application, so let's explore its many features.

Home screen

When you open the Google+ mobile application, you'll see the home screen (**Figure 9.1**). Much like with the Google+ website, you'll find nearly all of the main features of the application on the home screen.

The black toolbar at the top of your screen contains icons for Search, the Notification box, and options (**Figure 9.2**).

Search. As with the Google+ search bar on the website, you can search for individuals on Google+ as well as specific content. To change the filter from Posts to People, just touch the respective tab at the top of the search screen. The selected filter will display a highlighted blue bar below it.

Notification box. Much like the Notification box found on the Google+ website, this small red icon tells you how many notifications you currently have. When you tap the box, your notification screen appears, which shows more detail about each of your notifications (**Figure 9.3**). If you tap a notification, the specific post appears. You can always tap the Refresh icon in the top right of this screen to refresh your notifications in real time.

Colby's Quick Tips

When you tap the Notification box in the Google+ mobile app, it automatically resets the counter to 0. However, it will keep unread notifications in bold, allowing you to determine which notifications you still need to check out.

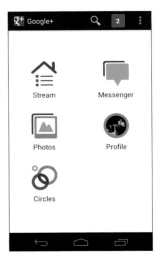

Figure 9.1 On the home screen you'll be able to access your Stream, Photos, Profile, Circles, and Messenger sections.

Figure 9.2 The top navigation bar gives you quick access to search for content, view your Google+ notifications, and view other options, which include creating a new post.

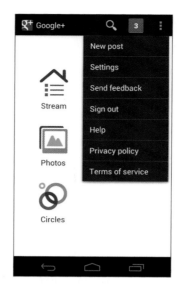

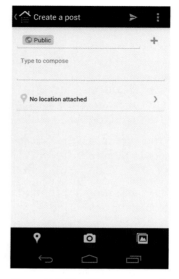

Figure 9.3 The stream of notifications is not endless but will allow you to scroll back to notifications from a few days prior.

Figure 9.4 The Option menu opens when you tap the Option icon in the top right of your mobile device's screen.

Figure 9.5 The "Create a post" screen allows you to create a post on Google+ that contains GPS coordinates, text, and multimedia (photo or video).

Option menu. Represented by three gray squares in a vertical line, the Option menu gives you quick access to alternative features from the Google+ mobile application home screen (**Figure 9.4**).

Note that the Option menu changes depending on the screen you are currently on. While on the home screen, you'll find the following options:

- **New post.** With this option you can easily create a new post and publish it on Google+ (**Figure 9.5**). The three sections on this screen provide options for your post:

 - The top box controls which circles you are sharing the post with. To add more circles, tap the + icon to the right of the box.

 - The middle box contains the words "Type to compose" and is where you write your post.

 - The bottom of the three boxes is your GPS location. If you have GPS turned off on your mobile device, it will display "No location attached." To add your current GPS location, tap the box. You'll then be given a list of options of various locations around you to include as a GPS marker on your post.

Figure 9.6 The black shortcut bar contains icons that enable you to easily toggle on GPS coordinates to your post, take a photo, or upload a photo from your mobile device's gallery.

- The three icons at the bottom of the screen represent your GPS location toggle and Camera and Gallery features (**Figure 9.6**). The GPS toggle automatically attaches your GPS location to the Google+ post you are creating. The Camera icon allows you to take a photo on your mobile device's camera and automatically add it to the post. The Gallery icon allows you to choose an image you have taken previously on your mobile device and attach it to the post.

- **Settings.** This option allows you to adjust Google+ Notification options, Messenger settings, and photo settings, and choose to sync your Google+ contacts with your phone.

- **Send feedback.** If a feature on the Google+ mobile application is not working properly or is missing, you can use this feature to send feedback directly to the Google+ engineering team.

- **Sign out.** This option is useful if you need to sign out of your Google+ account so that someone else can log in.

- **Help.** This option takes you to the Help website for Google+, where you can search for answers to any questions you may have about different Google+ features.

- **Privacy policy.** This option takes you to the website that details the Google+ privacy policy.

- **Terms of service.** This option takes you to the website that explains the Google TOS agreement in detail.

Stream

Stream

The Stream page is very similar to your home page on the Google+ website. Here you can view the published content from everyone you have in your circles as well as create your own post (**Figure 9.7**). The Stream page includes the top navigation bar, the Circle Filter bar, and the stream of content.

Top navigation bar. The top navigation bar allows you to check in at a location and create a post (**Figure 9.8**). To selectively filter out your stream, tap the Option menu icon in the top right of your screen and select "Choose circles." Here you can select which circles you want to view content from (**Figure 9.9**). Unlike the desktop version of Google+, you can

Figure 9.7 The Stream page on the Google+ mobile app allows you to view others' posts and create your own content.

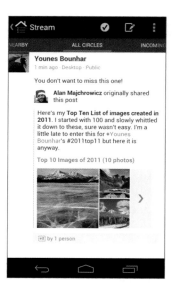

Figure 9.8 The top navigation bar allows you quick access to check in at a location, create new content, and return to the home screen.

Figure 9.9 The "Choose circles" feature in the Option menu allows you more control over filtering the content you view in your stream than anywhere else on Google+.

choose any combination of circles to filter. If you want to only see content from your Top Photographers and Colorado Photographers circles, no problem, just select those circles.

Circle Filter bar. Located just below the top navigation bar, this slightly lighter gray bar allows you to filter the content you see in your stream (**Figure 9.10**). To select one of the three filters, slide your finger across your screen to the left or right in the direction of the filter you want to view:

- **Nearby.** This filter shows you content that was published near your GPS location. If you do not have the GPS feature on your mobile device turned on, it attempts to locate your general whereabouts using your cell connection.

- **All Circles.** This filter displays published content from everyone you have in your Google+ circles.

Figure 9.10 The Circle Filter bar gives you quick access to filter the content of your stream by allowing you to view content from individuals nearby, from everyone you have circled, or from those who have circled you.

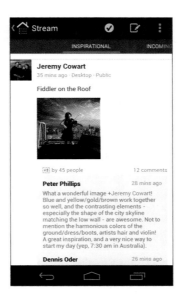

Figure 9.11 Your content stream allows you to view and interact with content that has been published to Google+.

- **Incoming.** This filter displays published content from people who are not in your circles but have you in their circles. It is a great way to find new and interesting people to connect with.

Stream of content. The stream of content area is where you'll find all of the content that has been shared with you by individuals and business pages on Google+. There are a handful of ways that you can interact with this content (**Figure 9.11**):

- Slide your finger either up or down on the stream to navigate through the post.

- Press the profile thumbnail or post author to go to that person's Google+ profile.

- Press and hold your finger over a post to bring up a menu that allows you to +1, share, or mute the specified post.

- Tap a post to bring up its content. You can then leave a comment on the post by typing in the bottom bar where the words "Type a comment" appear.

Photos

Photos

The Photos section of the Google+ mobile application allows you to easily view and interact with all of your uploaded photos and photos that are still on your phone, as well as the recent photo uploads of people in your circles.

On the main screen of the Photos section, you'll notice sectional thumbnails of various photo albums, most of which belong to you (**Figure 9.12**). However, you'll find three default photo albums on every Google+ account:

- **From your circles.** This album showcases images that have recently been uploaded to Google+ from anyone in your circles. It displays a maximum of 50 photo thumbnails.

- **From your phone.** This album acts as a gallery for all of the images currently on your mobile device. Because these images are not on Google+, you cannot interact with them.

- **Photos of you.** This album contains photos in which you have been tagged. It is meant to be a collection of images that have you in them.

To interact with an image, you must first tap the photo album that it resides in, and then tap the image. On the main image screen, the +1 button is located in the top right of the screen, and the photo information is located just under the photo. This information contains the artist's name, the name of the photo album, the number of +1's, and the number of comments the image has already received (**Figure 9.13**). When you tap the image, it will expand to the full screen size of your device. Tap again to return it to the standard position. To leave a comment, simply type your comment in the box located at the bottom of the screen; to +1 the photo, tap the +1 icon in the top right of your screen.

When you press the Option menu icon (Menu on iOS devices), several options appear (**Figure 9.14**):

- **Set as profile photo.** Allows you to set the current photo as your Google+ profile photo. This option is only visible when looking at your own images.

- **Set as wallpaper.** Allows you to set the current image as your mobile device's wallpaper. This option is only visible when looking at your own images.

- **Refresh.** Allows you to refresh the photo to showcase the latest photo data and interactions involving the image.

- **Delete photo.** Allows you to remove an image from Google+. This option is only visible when looking at your own images.

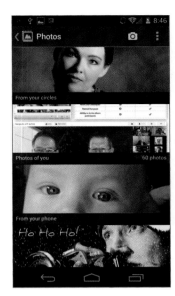

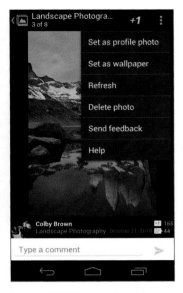

Figure 9.12 The Photos section displays thumbnail previews of all of your image albums in a seamless stream. Scroll down the screen to see more of your albums.

Figure 9.13 The view of an individual photo from within the Photos section allows you to view the statistics of those who have interacted with it as well as add a comment to the image.

Figure 9.14 The number of options available to you is dictated by whether the photo was uploaded by you or not.

Utilizing the Instant Upload Feature

The Instant Upload feature on the Google+ mobile app allows you to automatically upload your photos and videos directly to Google+ right after they are captured. They are placed in a private album, allowing you to choose which images or videos you want to share and to whom when you are ready.

To enable Instant Upload:

1. Press the Option menu (Menu on iOS devices).

2. Select Enable Instant Upload.

Once enabled, all photos and videos taken with your mobile device are uploaded to the "From your phone" album on Google+. They are visible only to you unless you choose to share them from a web browser or your Google+ mobile application.

- **Send feedback.** Allows you to send in feedback relating to the Google+ mobile application.

- **Report abuse.** Allows you to report the current image as abuse for sexual or explicit content as well as spam. You will not see this option if you are looking at your own image.

- **Help.** Allows you to access the Help system for the Photos section of the Google+ mobile application.

Profile

Profile

In the Profile section of the Google+ mobile app are three main tabs that allow you to view the content you have published, photos you have uploaded, and the profile information you listed on your Google+ profile from your desktop web browser:

- **Posts.** In the Posts tab (**Figure 9.15**) you can see an endless stream of all the content you have published on Google+. You can interact with your posts just as you can in the Stream section of the Google+ mobile app. A long press with your finger on a post will bring up a menu, allowing you to +1, share, or delete your post; a single finger tap will bring only that post into view.

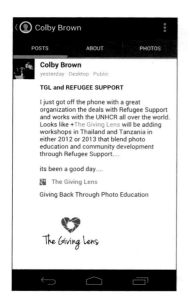

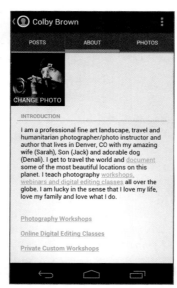

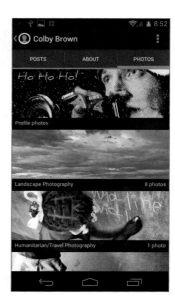

Figure 9.15 In the Posts section you can view all of your recent posts to Google+.

Figure 9.16 In the About section you can view your entire Google+ Profile page.

Figure 9.17 In the Photos section you can view all of the images you have uploaded to Google+.

- **About.** The About section (**Figure 9.16**) lists the information you filled out on your Google+ profile when you first signed up for the network. Although you cannot edit this information from the Google+ mobile app, you can change your profile photo by tapping your thumbnail located in the top left of your screen. You'll then have the ability to take a new photo with your mobile device's camera, choose a photo from your mobile device's photo gallery, or view the other profile photos you have used in the past.

- **Photos.** The Photos section (**Figure 9.17**) displays the various albums you have set up on your Google+ account. Tap an album to see the photographs inside. Tap again on a specific photo you want to look at more closely, and the photo will appear in a near full-screen view. By pressing the Option menu icon (on Android devices), you'll see the same options shown in Figure 9.14.

Circles

Circles

The Circles section of the Google+ mobile app allows you to maintain a fairly high level of control over your Google+ Circles. The main page is broken down into two tabs, Circles and People.

People. The People tab displays everyone you have circled on Google+ (**Figure 9.18**). The individuals are listed in alphabetical order and have the names of the circles they are in displayed below their name. At the top of the screen is the "Find & invite people" button, which allows you to find and connect with other people on Google+. It first displays a suggested list of people for you to circle, but by pressing the magnifying glass in the top-right corner of your screen, you can search for individuals manually.

Circles. The Circles tab displays all of the circles you have created for your Google+ account in alphabetical order (**Figure 9.19**). If you want to create a new circle, simply tap the Create New Circle button at the very bottom of your screen.

If you tap one of these circles, a new screen appears that acts as a filter for that specific circle:

- **People.** The People tab (**Figure 9.20**) allows you to view all of the individuals and pages that you have added to the currently selected circle. By using a long finger press on a specific profile, you'll have the option of removing that profile from the circle.

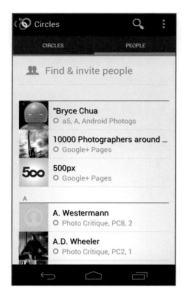

Figure 9.18 The People tab in the main Circle section displays everyone you have added to your Google+ Circles. It also allows you to add and invite new people to your circles.

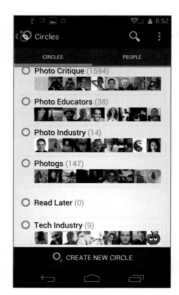

Figure 9.19 The Circles tab displays all of the circles you have created on Google+ in alphabetical order, making it easy to find the circle you want to interact with.

Figure 9.20 The People tab allows you to view, interact with, and remove any Google+ profile that is inside the currently selected circle.

At the bottom of the screen is an Add People button that allows you to add individuals and pages to the circle you are currently in. In the top right of the screen are two icons. The icon that looks like a pen and paper outline allows you to create a new post that will be shared with only the currently selected circle. The dialogue box with the + sign allows you to invite the entire circle to a group text chat via the Messenger feature on the Google+ mobile app.

- **Posts.** The Posts tab (**Figure 9.21**) allows you to view content that was published from only the selected circle.

- **Photos.** The Photos tab (**Figure 9.22**) offers a stream of 50 image thumbnails of the most recent photos uploaded only by those in the selected circle.

Figure 9.21 The Posts tab allows you to view all content published only by individuals in the currently selected circle.

Figure 9.22 The Photos tab displays photos that have been uploaded from individuals only in the currently selected circle.

Figure 9.23 In Messenger you can not only initiate group text chats with people, but you can start a Google+ hangout with those you are chatting with.

Messenger

Messenger

Messenger is a group text chat feature that is unique to the Google+ mobile app (**Figure 9.23**) and is not currently available on the desktop Web version of Google+. It allows you to easily host an online conversation with multiple individuals from all over the world.

To access Messenger, tap the Messenger icon on your home screen. A screen appears that displays all of the Messenger group conversations that you are currently in or have been invited to. To begin or to continue interacting with one of these group chats, simply tap the chat in question. When it comes to controlling these group chats, you have multiple options (**Figure 9.24**) available to you at the top of your conversation screen and in the Option menu:

Start a Hangout. Tap the icon that looks like a movie camera at the top of your screen to initiate a Google+ hangout and invite everyone inside the current Messenger chat.

> **Colby's Quick Tips**
>
> The Google+ Messenger feature is a phenomenal tool to help you collaborate on projects or plan a photography trip with a group of friends. All of the chat logs can be saved, and everyone can chat in real time to discuss important aspects of an upcoming trip, such as whose responsibility it is to bring the tent.

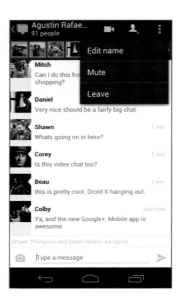

Figure 9.24 You have multiple options when it comes to interacting with a Messenger group chat.

Add People. Tap the icon that looks like a dialogue box with a + symbol if you want to add more people to the Messenger chat.

- **Option menu.** Tap the Option menu icon to view more options:

 - **Edit name.** If you created the group chat, you have the ability to edit the name of the Messenger chat.

 - **Mute.** Use this option if you don't want to receive message notifications from a specified conversation.

 - **Leave.** When you leave a chat, you'll no longer receive messages from that conversation and won't be able to access or view the history of the conversation unless you are invited back.

 - **Hide.** When you hide a conversation, you remove the chat listing from your main Messenger stream. If you start a conversation with that person again, you can pick up where you left off. This is only possible with a one-on-one conversation.

To start your own conversation, tap the icon in the top of the main Messenger screen that looks like a dialogue box with a + sign. The "New conversation" screen appears. Simply type the name, email address, or circle that you want to send a chat invite to (**Figure 9.25**). When you are ready, type your message in the box located at the bottom of the screen where you see the words "Type a message."

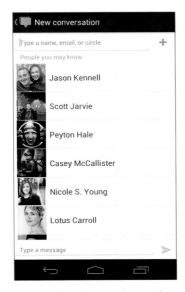

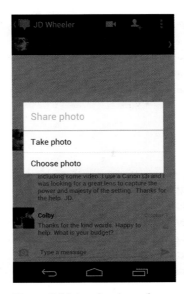

Figure 9.25 You can choose the name of a Google+ circle or an individual when selecting who you want to invite to a Messenger conversation.

Figure 9.26 It only takes a few simple steps to share a photo in a Messenger conversation.

Figure 9.27 After you have selected the image you want to share, just tap Choose to share the photo with everyone in the Messenger chat.

Also from within a Messenger conversation, you can share a photo already on your phone or take one right there and then (**Figure 9.26**).

To share photos, just follow these steps.

1. Tap the Camera icon located in the bottom left of your screen.

2. Decide if you want to take a new photo or choose a photo from your mobile device.

3. When you've selected the photo you want to share, tap the Choose button (**Figure 9.27**).

> **Colby's Quick Tips**
>
> Because of Google's restrictions on the number of people you can notify in a single post on Google+, you can only send a Messenger chat request to a maximum of 100 people initially. A circle that contains over 100 individuals will not work.

Jacob James:
What Google+ Means to You

As a young photographer based in Stoke-on-Trent, United Kingdom, I have a passion for black-and-white landscape and documentary portraiture. Currently, I am looking to expand my work into the NGO sector so that my images can hopefully make a difference to those less fortunate. My photography is inspired greatly by the incredible work of Steve McCurry, Ansel Adams, and Chris Rainier.

Website: *http://jacobjamesphotography.co.uk*

Google+: *https://plus.google.com/110426489614941682595*

Essay

By nature, photography connects people. Whether that is in the offices of Wall Street or the streets of Mumbai, one photograph can bring people together. Throughout the last century, images and photographs have transformed the lives of nearly every person on the planet. Photographs have been credited for changing laws, stopping wars, increasing aid funding, and many more amazing feats.

Google+ is rapidly transforming into an incredible platform to bring photographers worldwide together to discuss and debate subjects that matter. It is not always just about their work. I've seen some extraordinary debates on political and technology topics as well. As a platform, Google+ allows photographers to gain inspiration, critique, advice, and new friends along the way. Google+ has opened new pathways and opportunities I could have only dreamt about 12 months ago. It has also spawned some amazing projects and organizations that have started to make a difference to the world already.

The key ingredient to Google+ is the community; the people on Google+ are what make it what it is. Google has given us a near blank canvas to create a social network ourselves, and as creative people, we have relished that. It does not force us into doing things a certain way like other sites do; we have all shared the task of creating an exciting, creative, inspirational, and worldwide community where everybody, no matter who they are, can contribute and learn.

Hangouts

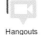

Hangouts

Although there is currently no dedicated icon on the home screen for hangouts on the Google+ mobile app, you still have the ability to both join and start a hangout.

To join a hangout. As you scroll through your stream via your Google+ mobile app, you'll see a post that has a blue button marked "Join hangout" (**Figure 9.28**). When you tap that button, a screen appears that allows you to adjust the position of your cell phone to make sure you are in the best light to be visible to others in the hangout before officially entering the hangout. When you are ready, tap the "Join hangout" button to join.

To start a hangout. To start a hangout, you must be inside the Messenger feature of the Google+ mobile application. Once you have started or joined a Messenger conversation with at least one other individual, you'll notice an icon at the top of the screen that looks like a movie camera. When you tap that icon, you'll launch a hangout and automatically invite everyone in the current conversation. Note that you are still limited to only a total of ten individuals inside a hangout, so the first ten people to join the hangout will be allowed to participate.

When you are in a hangout, you'll notice thumbnail images of the other hangout participants at the top of your screen, and your live camera will be shown at the bottom (**Figure 9.29**). If you tap one of those thumbnails, a small menu appears containing four options:

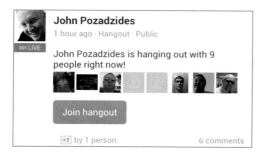

John Pozadzides
1 hour ago · Hangout · Public

John Pozadzides is hanging out with 9 people right now!

Join hangout

+1 by 1 person 6 comments

Figure 9.28 Pressing the "Join hangout" button allows you to jump into any hangout you come across in your streams on the Google+ mobile application.

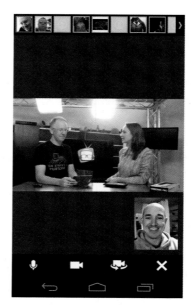

Figure 9.29 Jumping into a Google+ hangout from your mobile device is a great way to stay connected with your followers. I've hosted hangouts from my cell phone while shooting a sunset in the mountains of Colorado.

- **Profile.** This option takes you to the person's Google+ profile while you remain in the mobile hangout.

- **Pin Video.** This option pins the main video screen on this individual. With no one "pinned," the Google+ mobile app will try to automatically change the focus of the main screen onto who is speaking at that time.

- **Mute.** This option mutes the selected individual.

- **Block.** This option is the same as the Block feature in Google+. By blocking the person, you will no longer see or hear the individual and the person will be added to your Google+ blocked list, effectively cutting off all communication.

At the bottom of the main Hangout screen are four icons that allow you to control your experience in the Google+ mobile hangout. From left to right, you'll see:

- **Mute Audio.** This option mutes your own audio.

- **Mute Video.** This option mutes your video, covering it with a blank black screen.

- **Switch Cameras.** Most cell photos have front- and back-facing cameras. Enabling this feature switches the camera you want to be in use for the hangout.

- **Exit Hangout.** This option completely removes you from the Google+ mobile hangout.

The Value of Staying Connected

I'll be the first to admit that there are times when I truly enjoy my solitude. No smart phones. No email. No Photoshop. Just the beauty of this planet, my camera gear, and me. As a landscape, travel, and humanitarian photographer who works well off the grid at times, I am used to working in environments with no electricity, Internet, or even clean drinking water. However, even in these situations, I always plan ahead, figuring out new and creative ways to stay engaged with those who follow my photography work (**Figure 9.30**).

Much like life, social networking and marketing are dynamic and always changing. On Google+ alone, well over 100 million people connect, share, and post various types of content. As mentioned in Chapter 2, not only are original and creative ideas vitally important to building a brand and a following, but so is consistency. In the digital world, taking a break for a week can have a lasting impact. To stay relevant, you have to consistently push out content that keeps your followers intrigued. Although maintaining that interest on the road is certainly challenging, it offers a great opportunity to take your followers with you.

Colby's Quick Tips

Along with consistency, original and creative ideas are worth their weight in gold on social networks. It is difficult to stand out if you are constantly doing the same things as everyone else. Think outside the box and come up with unique ways to keep your followers engaged.

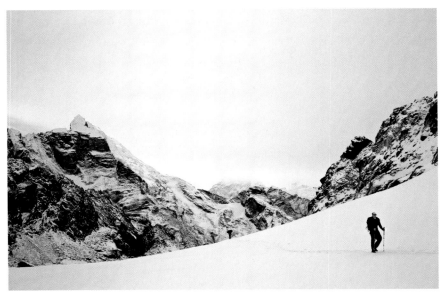

Figure 9.30 When I'm working in a region such as the Himalayas, I have to plan ahead when it comes to documenting my trip, especially because electricity is scarce. I often carry a solar panel, a satellite phone, and a GPS tracking device, which allow me to send short communications back home and give my followers the ability to follow my GPS coordinates in real time.

Taking Your Followers Behind the Scenes

Let's face it; the idea of being a photographer is very romanticized. Often, people think that my life consists purely of traveling around the world and documenting exotic people and places. In reality, there is almost always a lot more to an image than just the final result. People want to know that backstory. They want to know the process.

Although not everyone might have experienced a stomach virus because of tainted meat while on a photo trip or camped out for six days in snow and rain while waiting for the right light in Southern Patagonia, there is always a story to tell. For example, while taking a hike through your local state park, you might want to take notes on the challenges you faced when trying to photograph the wildlife in the area and how you overcame them.

The Google+ mobile application provides you with multiple opportunities to share content and connect with Google+ users. You can send in trip reports, comment and interact with followers, and use the GPS radio on your phone to pinpoint your locations while you are on the move.

This "extra" content helps your followers develop a deeper connection with you and your work. People like to feel involved, so tell your story!

Engaging in Mobile Hangouts

As discussed in Chapter 8, Google+ hangouts are one of the most unique and compelling aspects of Google+. Having the ability to video conference with up to nine other individuals (ten in all) from all over the globe is a great feature that allows you to connect with people in a much more intimate way than you can on any other network. However, just because you are away from your computer, doesn't mean that you have to miss all the fun.

Colby's Quick Tips

Although you can only start your own Google+ hangout within the Google+ Messenger feature on a mobile device, there is a workaround if you have a laptop. If your cell phone allows for tethering, you can connect your cell phone to your laptop to give it Internet access. I've hosted many Google+ hangouts from my laptop while up in the mountains in locations with 3G cell service.

As mentioned earlier, with the Google+ mobile app for both iOS and Android devices, you have the ability to join any hangout in progress as well as start your own hangouts through the Messenger feature. I've had people jump in my Google+ hangouts from a train, in a car, and while walking around their neighborhood. As long as you have a solid 3G connection, it should make for a very pleasant experience.

Behind-the-scenes Images

Photographers often are so focused on the art they are attempting to create that they forget to document the process. I always make sure that I have my pocket-sized point and shoot camera or my cell phone easily accessible when working in the field. These portable cameras take pretty good images because of the advancements in technology, and they are quick to operate and easy to store away.

One of my favorite behind-the-scenes images is of my camera setup. While I am shooting, I'll often leave on the LCD on the back of my main camera to display one of the images I recently captured. This allows the viewer to see what I saw as I was capturing a scene (**Figure 9.31**).

Figure 9.31 When photographing Patagonia in southern Argentina, I was able to take this image of my camera setup as I captured the sunrise one morning. Instead of having to wait months before I had time to process the image, I was able to share this image with my followers not long after I took it, allowing them to come along with me on my adventure.

Elia Locardi:
A Photographer's Perspective

Armed with his camera, tripod, and no doubt a giant cup of coffee, Elia Locardi traverses the globe full time looking for interesting photographic opportunities and the stories that go along with capturing them. With each photograph, his goal is to share his vision with others so they can experience these places the way he does, full of color and emotion, depth, and texture. He hopes to inspire people to travel, to visit these beautiful locations, and to fall in love with the beauty of the world.

Website: *http://blamethemonkey.com*

Google+: *https://plus.google.com/u/0/112957708071337353347/posts*

Q As a travel photographer, why do you feel it is important to stay connected while on the road?

Well, after flying over 220,000 miles in 2011, it would be easy to just disconnect from everyone and live in my own little jet-lagged bubble. With this type of rigorous travel schedule and a business to run, staying connected is one of the biggest challenges I face. Because I'm nearly always on the road, it can prove difficult at times depending on the country I'm in and the availability of

a reliable Internet connection. But it's extremely important to me, and my business, to stay in close contact with all of my clients, online followers, and friends. Above all, I want them to know that I'm always available, even though I might be 10,000 miles away. This means responding to their questions, comments, and mentions; interacting on posts by others; and maintaining a connection with the online community, no matter where I am in the world.

Q Using the Google+ mobile app, how do you stay engaged?

Although I spend a lot of my time in different locations around the world, much of it's spent traveling between them. Often, with short layovers, I don't have much time available to get work done online, so I can't always pull out my laptop to respond to messages. With these brief windows of time, I have to be a social media ninja, using the Google+ mobile app for my iPhone to stay in contact. When time is tight, it is the sharpest weapon in the ninja arsenal. It allows me to quickly make and reply to comments and mentions, check out the posts of people I'm following, and to simply maintain contact with the online Google+ community.

Q What are some of your favorite Google+ mobile app features?

I'm consistently impressed with the responsiveness of the Google+ mobile app. The Notifications menu updates extremely fast, giving me the opportunity to keep up with the interactions on my posts in real time. With a quick scroll and a tap, I can easily reply to all of the comments, questions, and interactions.

The other key feature lies in its simplicity. Although it's feature-rich, there are no complicated menus to navigate. Everything is right there for you, making the Google+ mobile app feel very intuitive. I can easily get the job done with a limited amount of time, which is an absolute must for my crazy life on the go.

Q What piece of advice do you have for photographers just getting started with Google+?

Don't ever feel like it's too late to start. I know it can be a little intimidating when you see some of the photographers with large followings. Keep in mind that the one thing they all have in common is that they all began by creating a Google+ profile and uploading their photos.

Take the first step by fully developing your Google+ profile and populating your photo galleries with your best images. This is your first point of contact with the Google+ community, so make sure that it accurately represents you and your photography style.

Take time to interact and build connections. Google+ is an online community, and like any community, you will find you gain connections by being connected. So be a participant, respond to comments and mentions, and stay engaged in the community around you.

Mark Waslick:
What Google+ Means to You

Mark Waslick is a Vermont-based photographer who focuses primarily on landscapes and nature. Whether capturing grand landscapes or subtle details, his photography portrays a passion for the outdoors that began at a young age. Although New England is home, he travels whenever the opportunity presents itself to discover what the world has to offer.

Website: *http://mwwphotography.500px.com/#/0*

Google+: *https://plus.google.com/u/0/113944846007907559686*

Essay

Google+ is an extraordinary community for photographers, but I can only describe what it is to me. I'm a relative newcomer to both photography and social networks, so when I first created a minimal Google+ profile, I was equally unsure of my art and my place in Google+. I only hoped to become a better photographer, and Google+ was where the best photographers were sharing their work and their ideas. What I soon found, however, was much more. Here was a community of wildly creative and passionate artists who were effusive in their support and generosity. Their passion was inspirational. Surrounded by this incredible work and supportive mentors, my own photography improved, not at a crawl as it had been, but by leaps and bounds. I began to share a few of my photographs and was honestly surprised when they attracted a few comments. I started to share with increasing frequency, not for the comments or the +1's, but because I found that it completed the creative process for me. Google+ gave me the outlet that I needed. Nowhere else can one find the equality in which established, successful artists literally share the same page as floundering novices—and they are all welcome. Once you realize this, it sets you free. I know it did for me. Rather than Google+ being an extraordinary community for photographers, I've found that Google+ has become an extraordinary community because of the photographers.

I continue to be inspired by what I find on Google+, and it pushes me. Not a day goes by that I don't find inspiration in the raw beauty and humanity that appears in my stream. I discover where I want to take my photography and how I might get there. And that's exciting!

Index

A

About tab
 Google+, 56–57
 Google+ mobile, 197
account information. *See also* Profile; sign-up process
 navigation bar menu, 67–68
Additional Profile Information page, 44
aesthetics
 importance of, 10–11
 layout and design, 11–12
album organization
 Google+ mobile, 194–195
 image covers, 157–159
 moving photos between albums, 151–153
 renaming, 155–156
 reordering display of, 159–161
Android, Google+ mobile, 188, 203, 206

B

backstories, 120
 behind-the-scenes view, 206–207
 original and creative content, 130–131, 138
"Best New Technology Podcast" TWiT Photo, 100
Blame The Monkey website, 208
Block feature
 from hangouts, 115, 204
 from posts, 114–115
 from profiles, 113–114
 results of, 113
boldface text, 98, 121
brands/branding for photographers
 content's importance, 27–29
 creating, 26–27
 engaging others, 31–32
 focus on others, 29, 31
 sharing personal info, 30

C

Camera feature, Google+ mobile, 191
Chat feature. *See also* Messenger feature
 Hangouts, 172
 joining with Google Chat, 184
 Hangouts with Extras, Group Chat, 176
Circles feature, 9–10, 12
 connections, 81
 creating, 80–84
 definition, 76–77
 Extended Circles, 90, 122
 filters, 77–78, 192–193
 Google+ mobile, 192–193, 197–199
 limits, 81, 88
 organizing, 77–78, 82, 94
 potential types, 84
 privacy controls, 48–49, 57, 69–70, 122–126
 profiles
 Profile information, 51
 removing with Circles page, 86–87
 removing with Profiles page, 87
 Public Circles, 89–90, 122
 renaming, 84–85
 reordering, 85–86
 setup guidelines, 79
 sharing, 88
 social relationships, 63
Cohen, Dave, 18–19
comments
 disabling, 125–126
 Google+ mobile, 193–195, 208–209
 posting, 97–98
 reporting spam, 112
community managers
 Google+, 17
 Google+ mobile, 21

"Contributor to" section, Profiles, 53–54
copyright of photographs, 16–17
Creative Kit, 153–154
curators, 143

D

Daily Photography Themes, 139, 141–142
Dell, Michael, 167–168
Di Fruscia, Patrick, 56, 144–145

E

email/messages, 51
Extended Circles, 90, 122

F

Facebook *versus* Google+, 4–6, 11
feedback buttons
 Google+, 23
 Google+ mobile, 191, 196
filters
 for circles, 192–193
 in searches, 106–107
 for streams, 94
500px *versus* Google+, 4–6
Flickr *versus* Google+, 4–6, 11

G

Gallery feature, Google+ mobile, 191
The Giving Lens page, 46
Gmail, "Search Plus Your World" initiative, 7
Google+
 +1 button, 8
 interacting with content, 58–59
 recommending posts in Streams, 102
 aesthetics
 importance of, 10–11
 layout and design, 11–12